Den's Doodles
Regular & Captionated

Copyright © 2017 by Dennis Preston
All rights reserved
ISBN 978-1-365-66365-9

Also available from

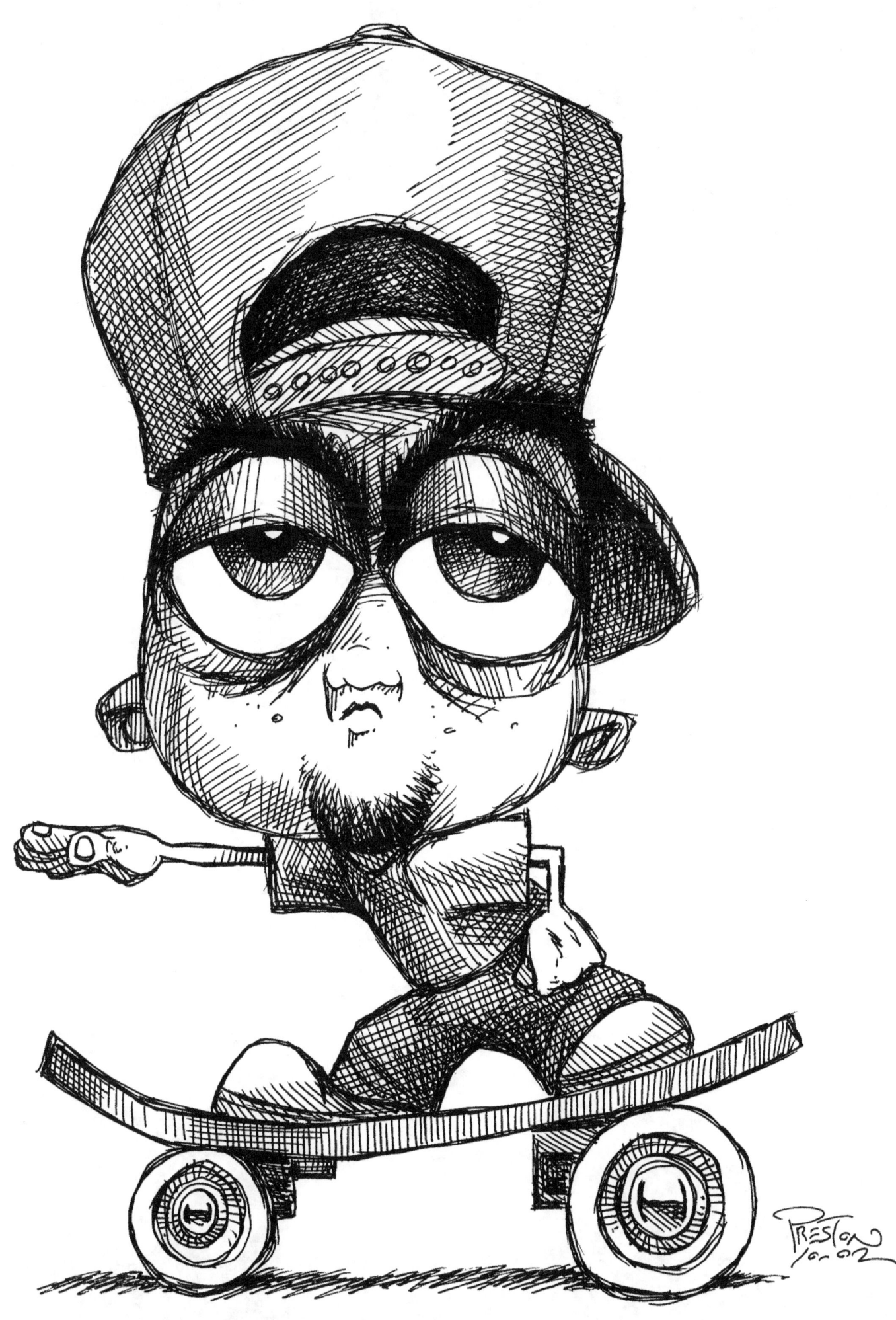

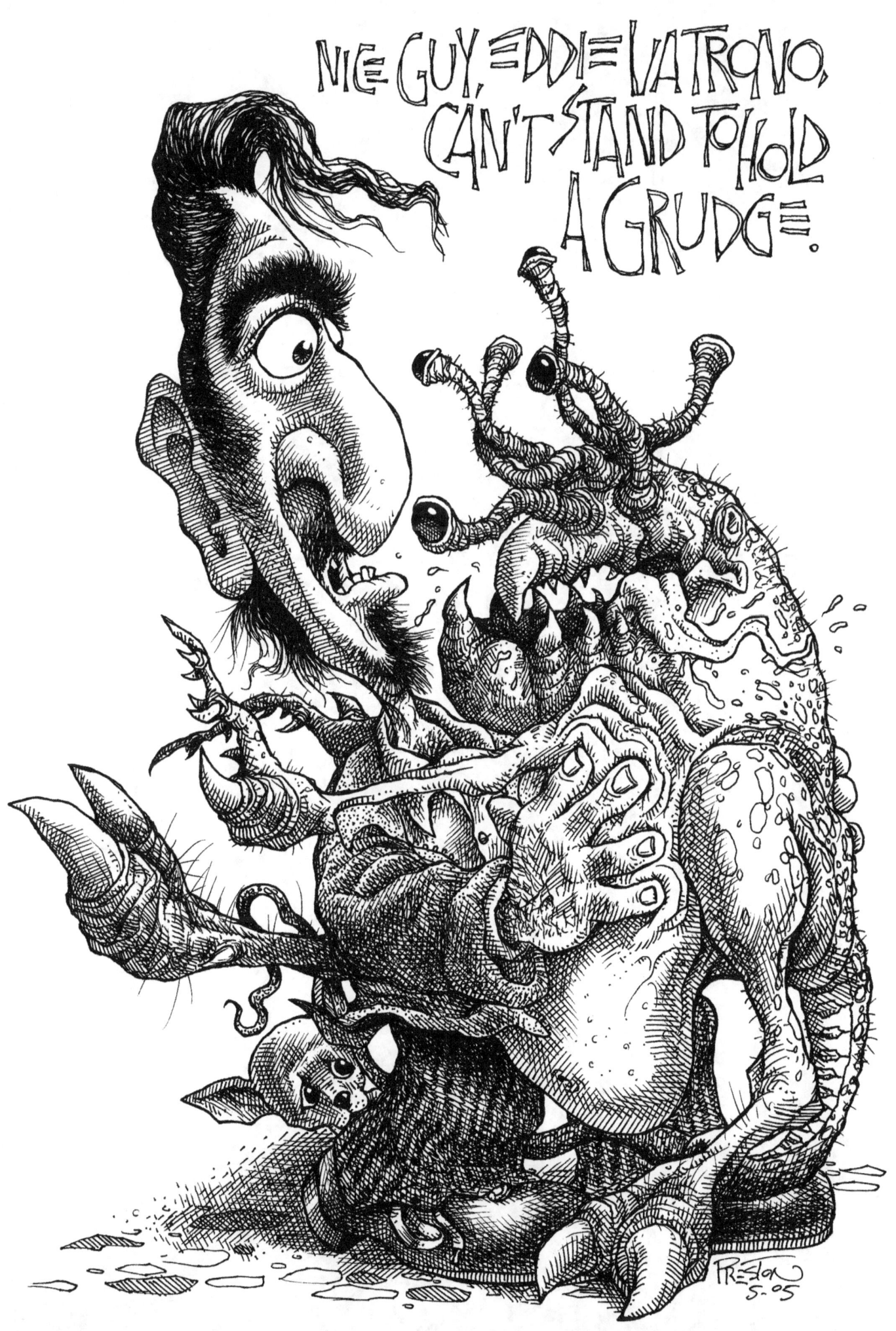

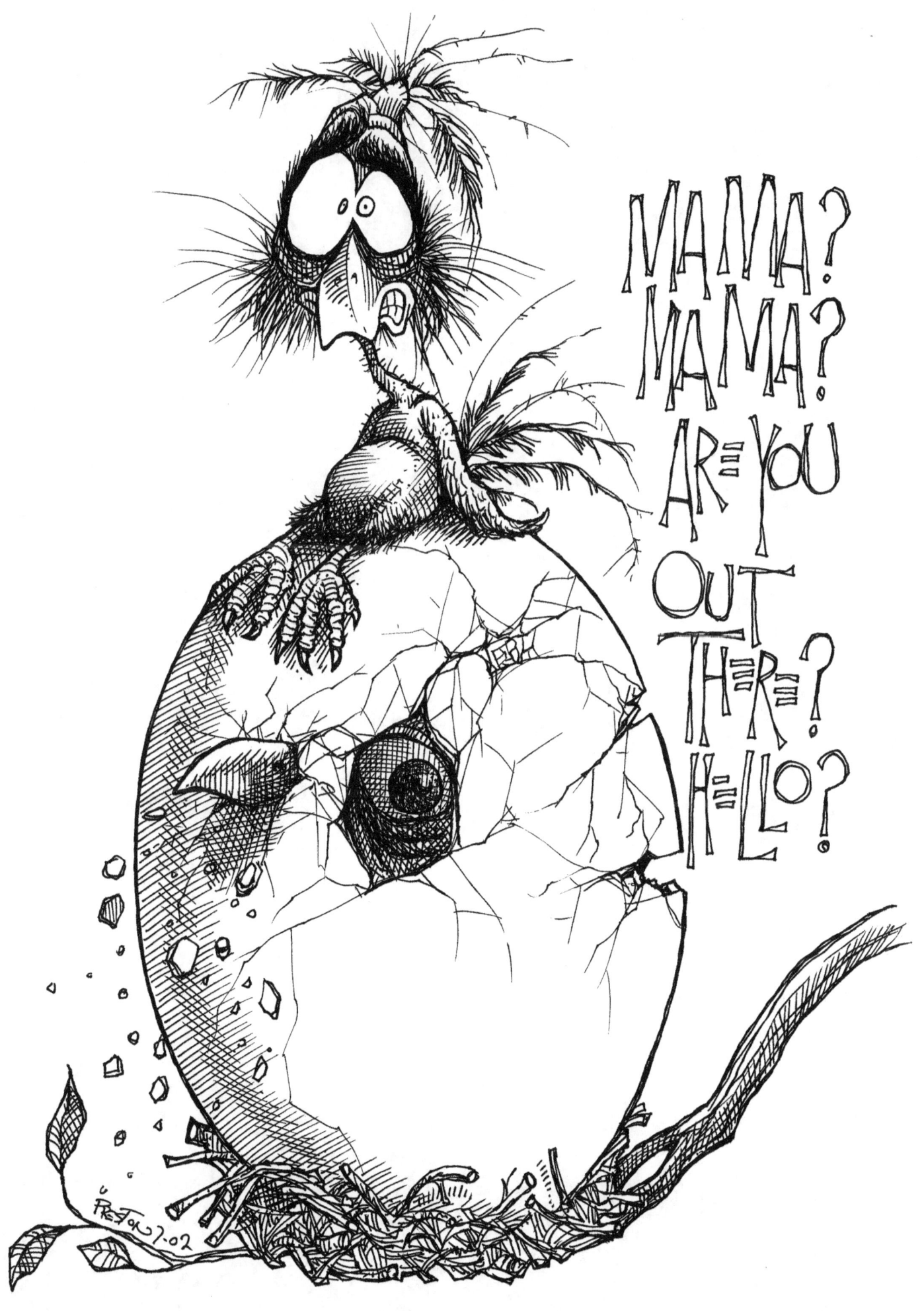

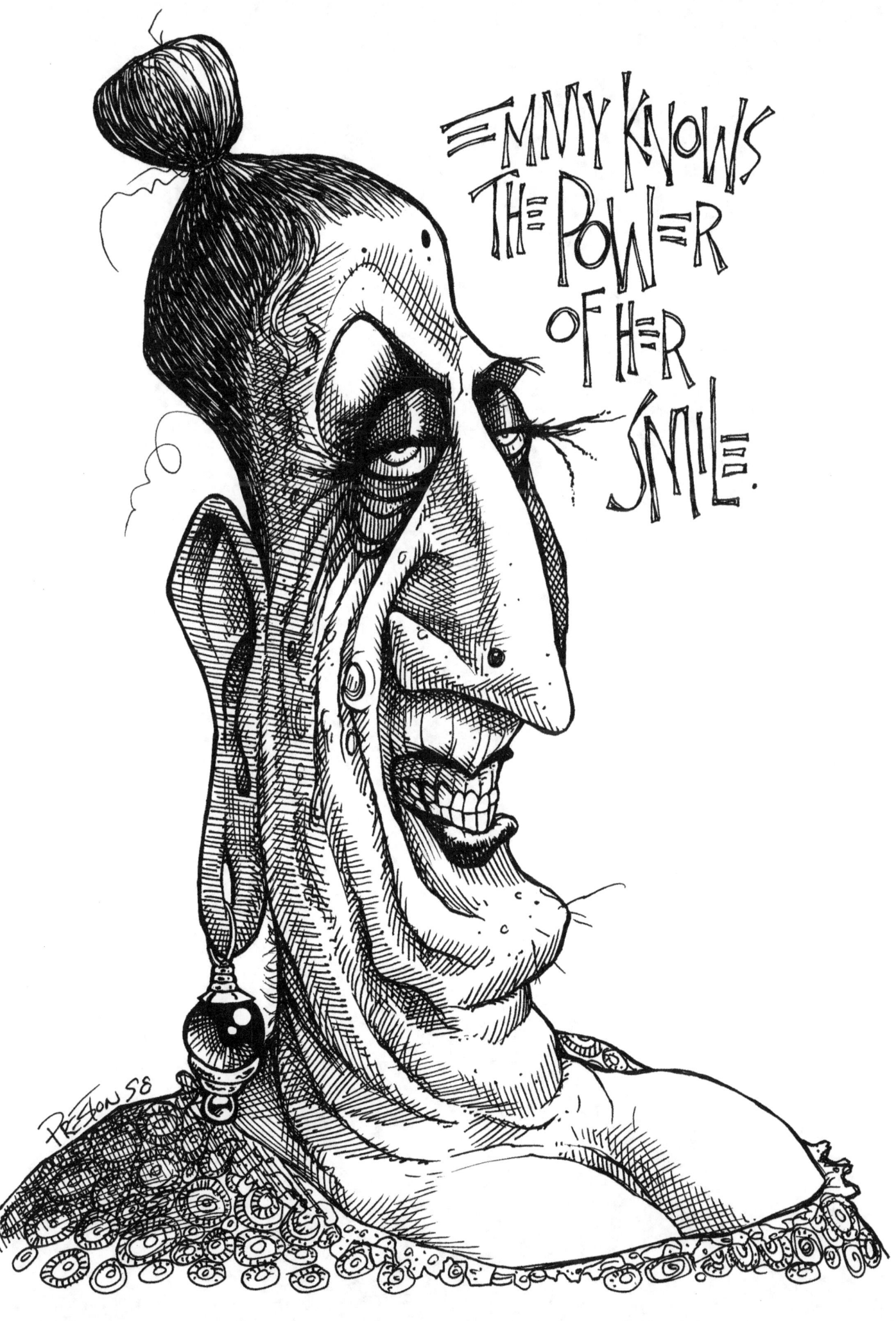

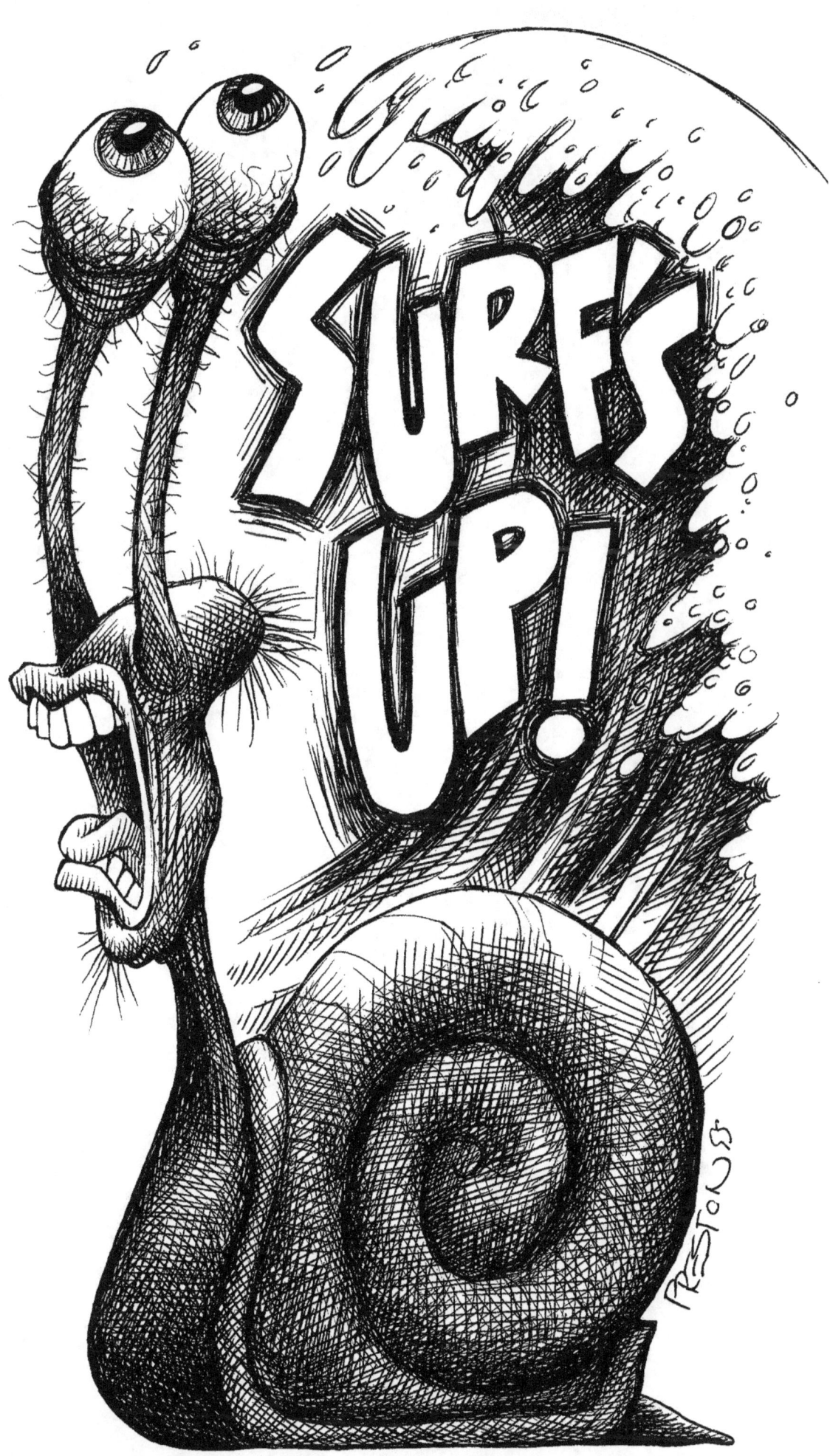

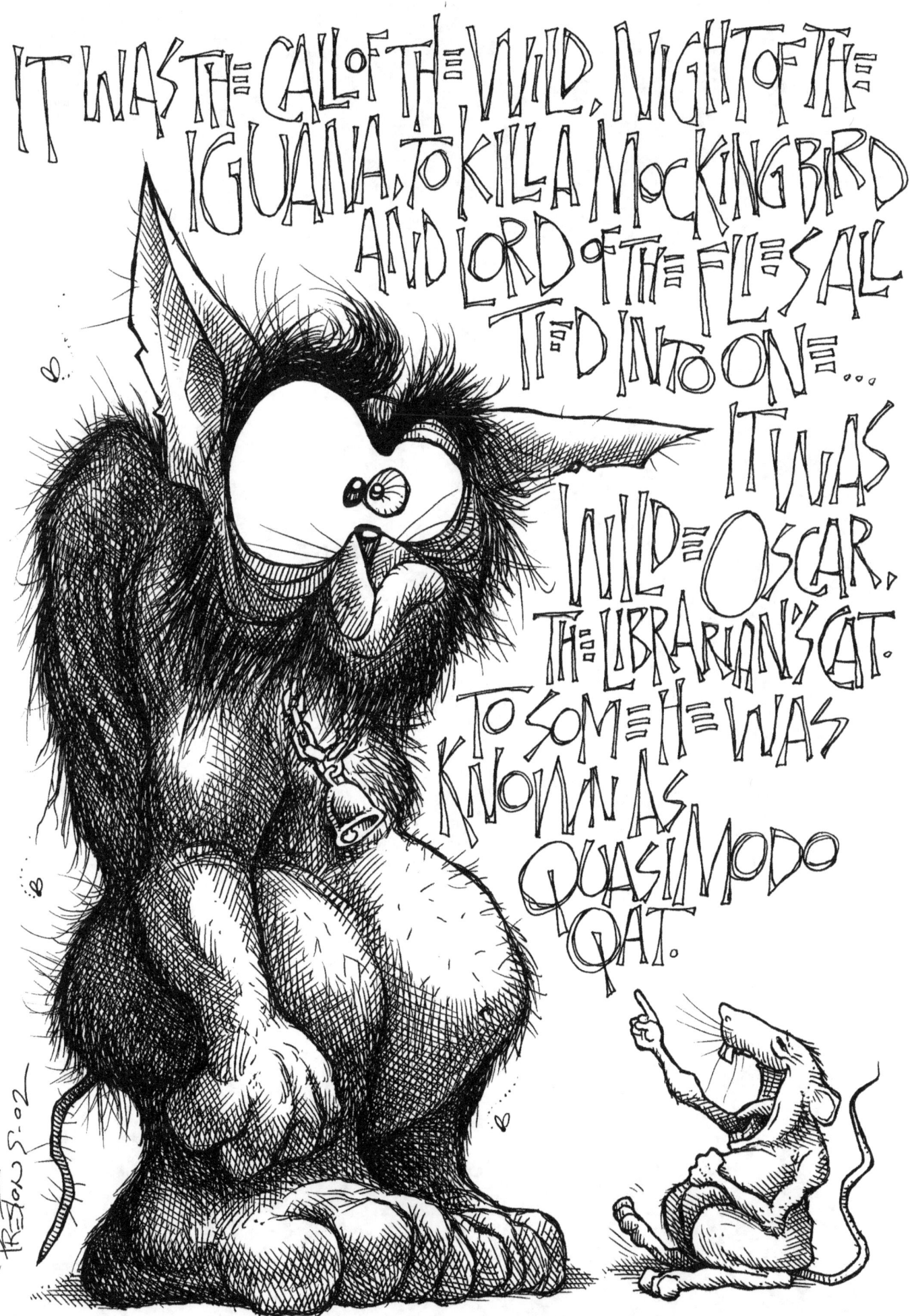

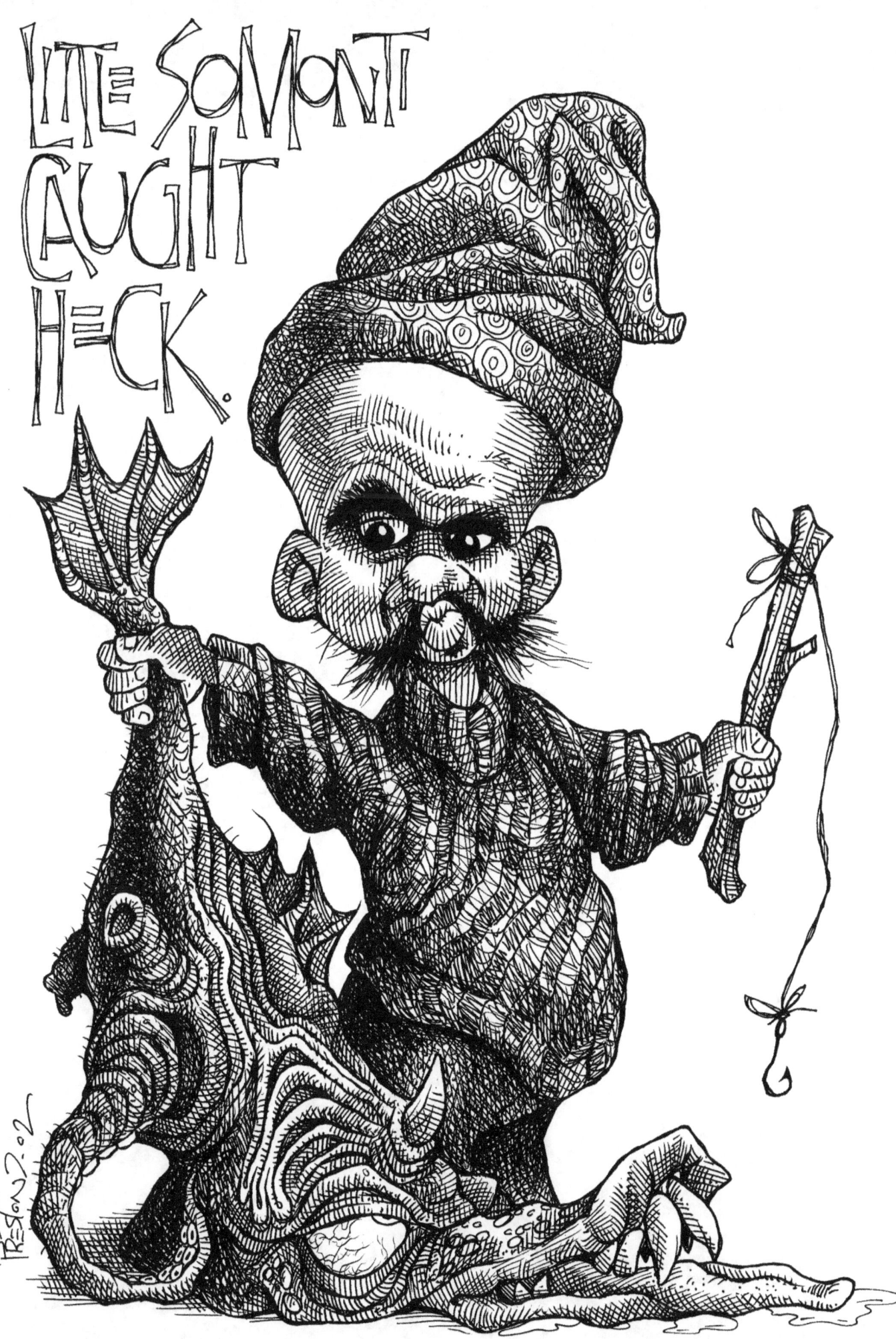

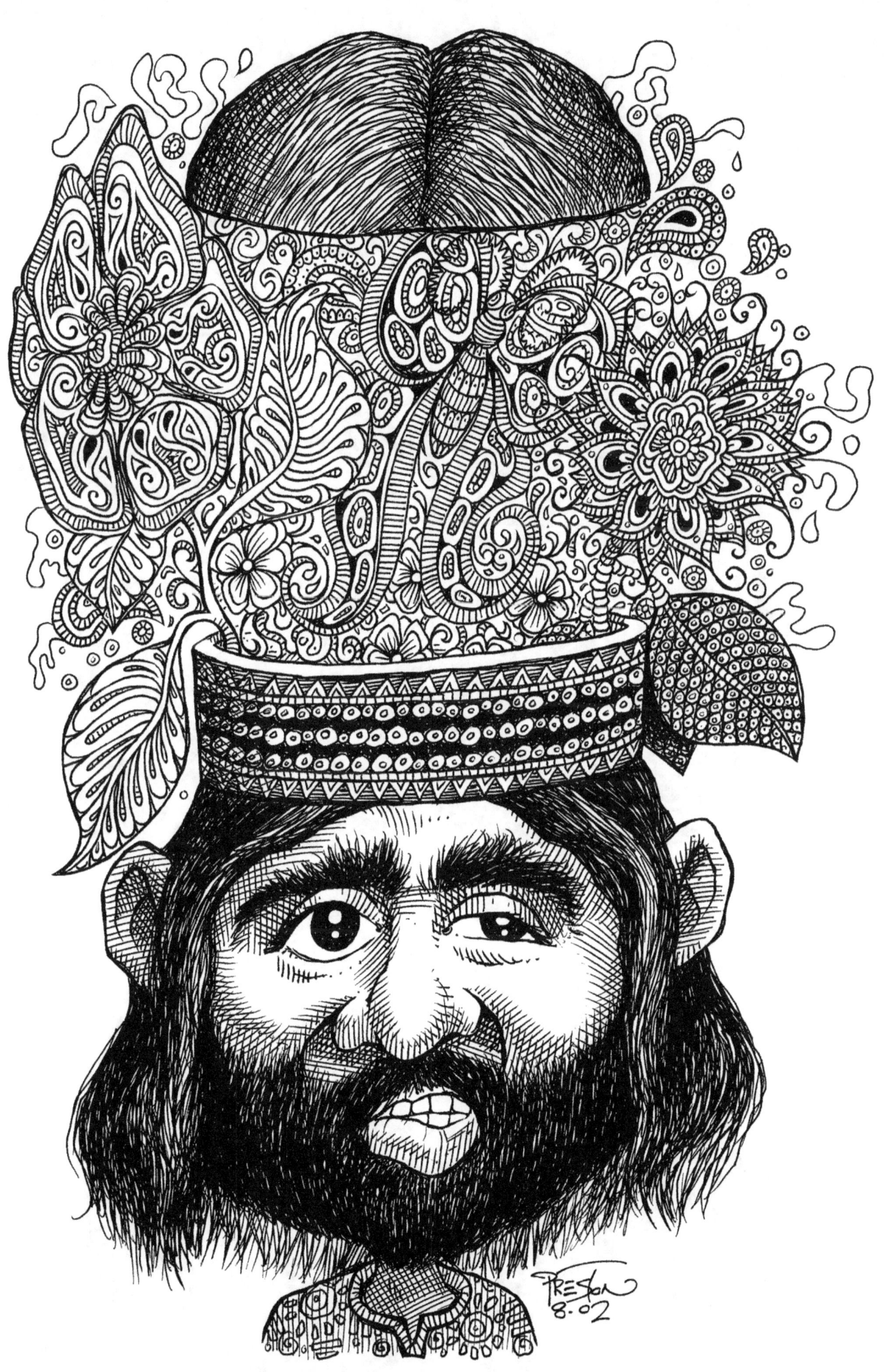

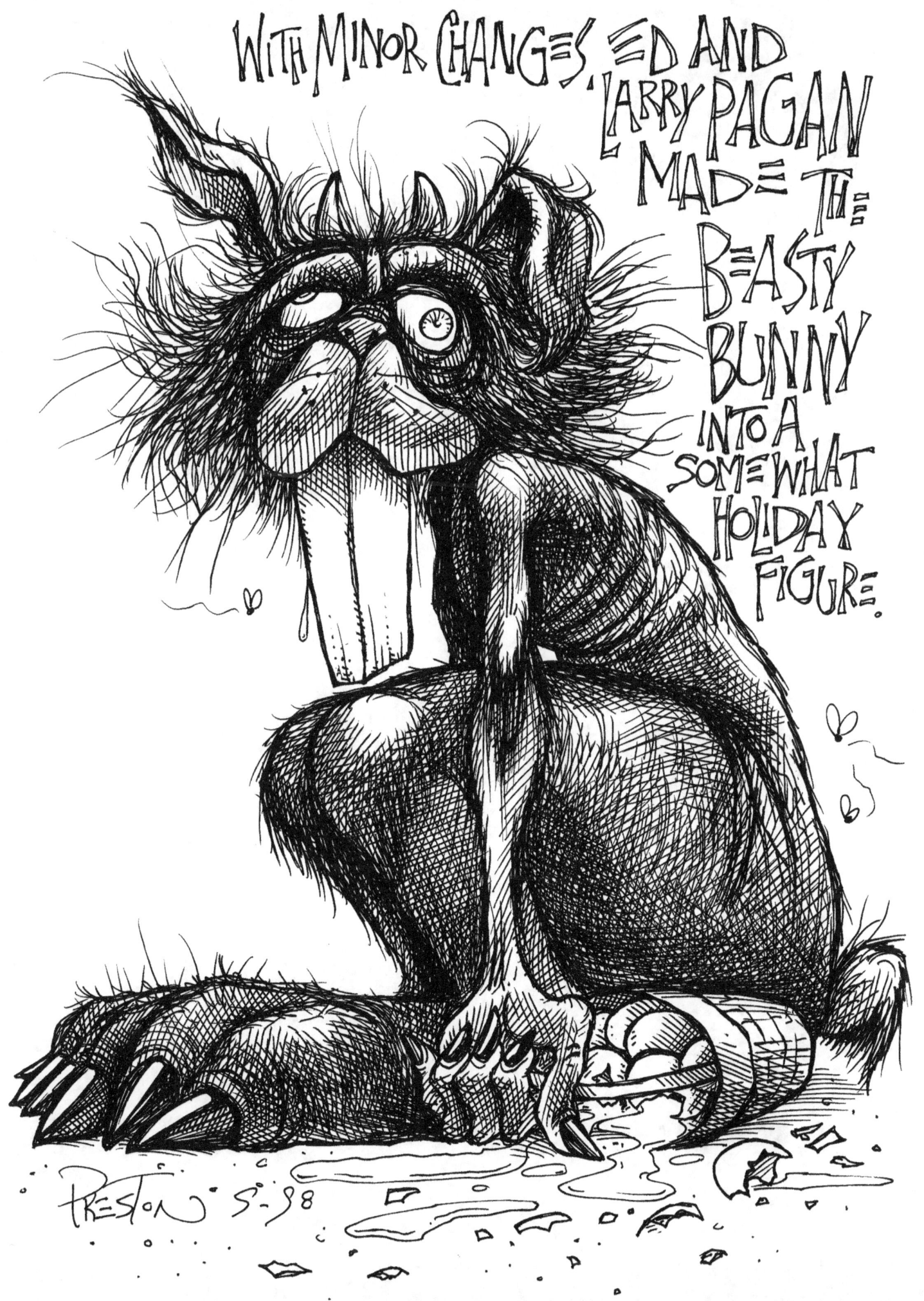

WHEN LITTLE SID, A FLOWER CHILD OF THE 90'S, HEARD HIS NAME CALLED, TURNED HIS HEAD AND WAS MET WITH A FLYING POOTY OF SORTS.

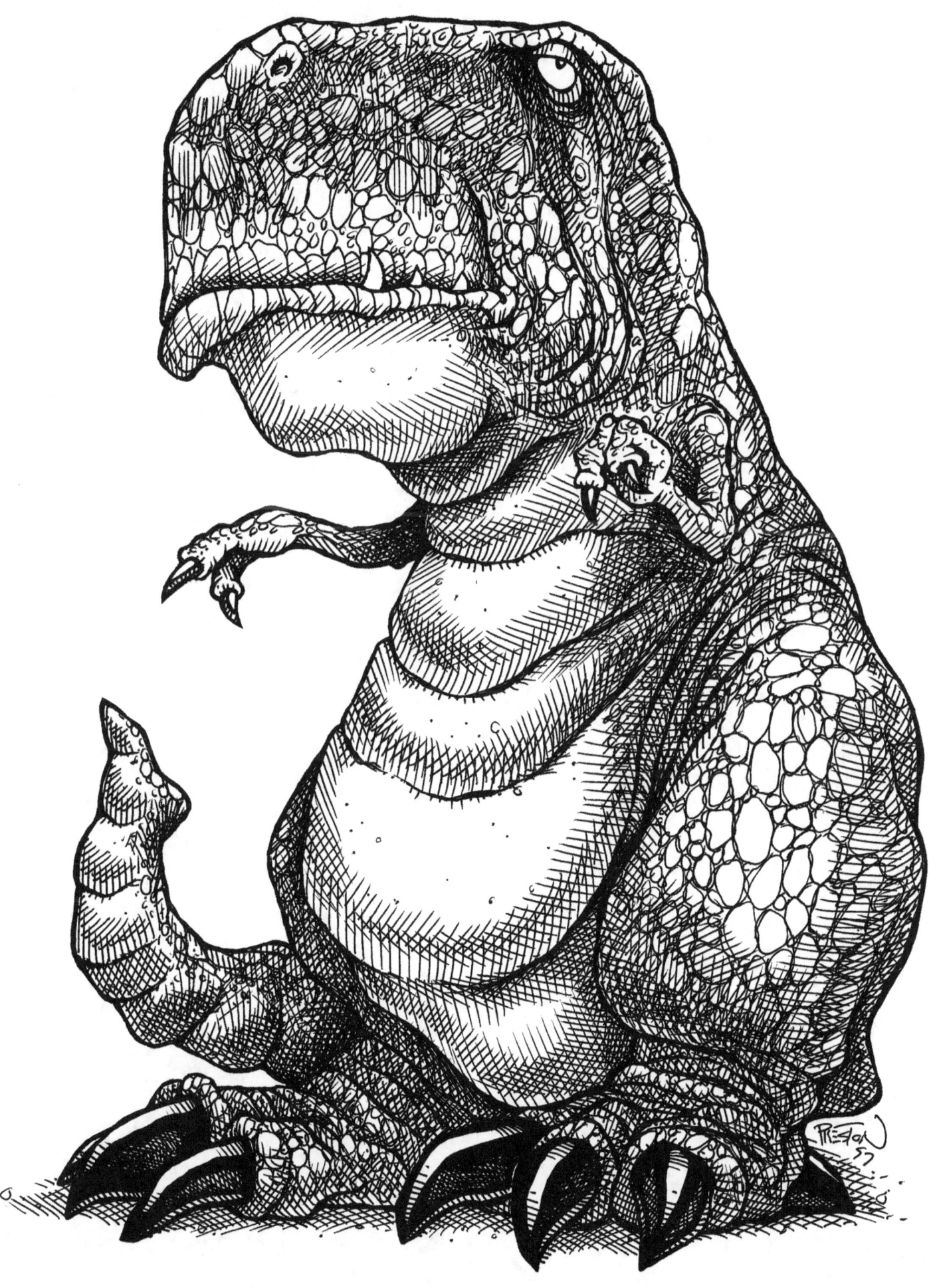

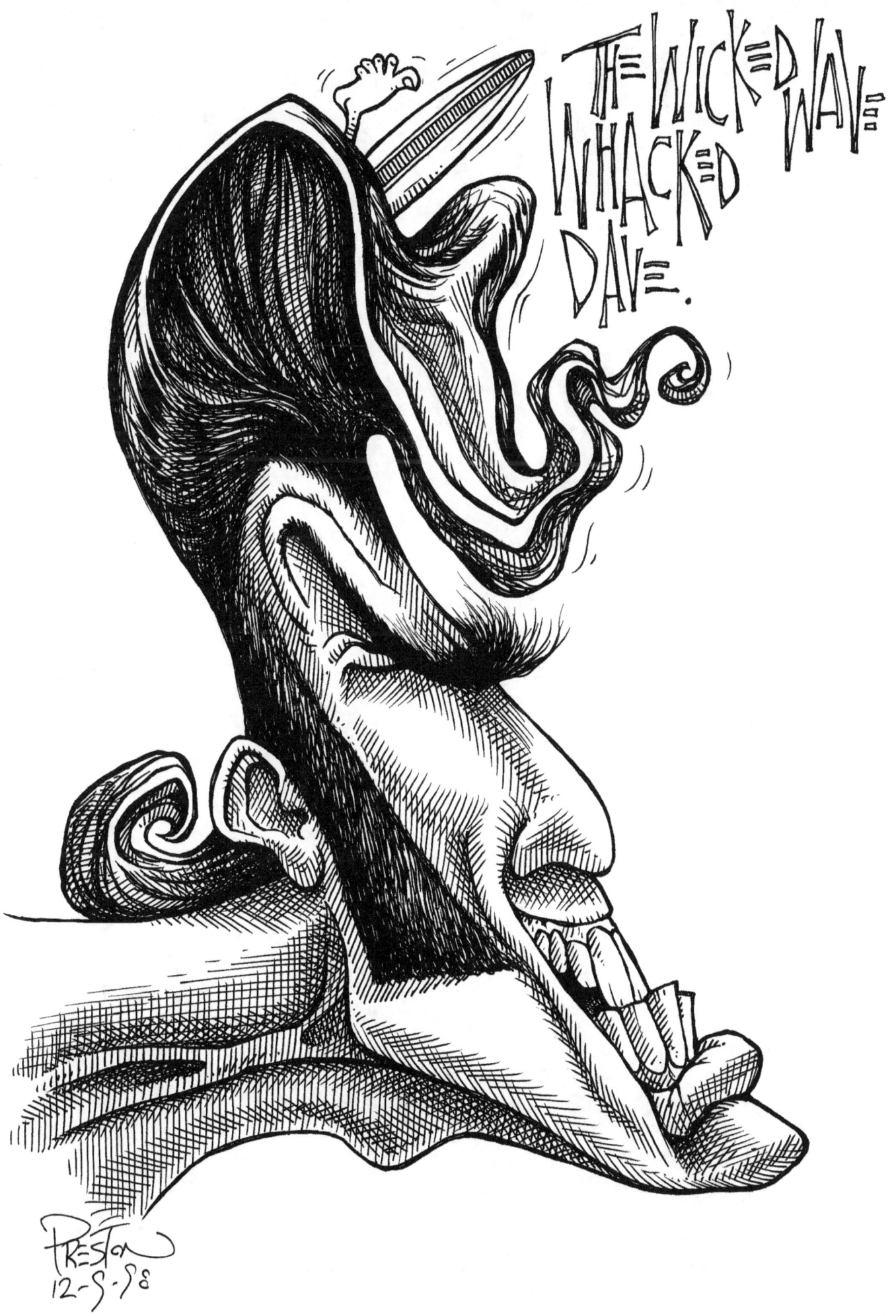

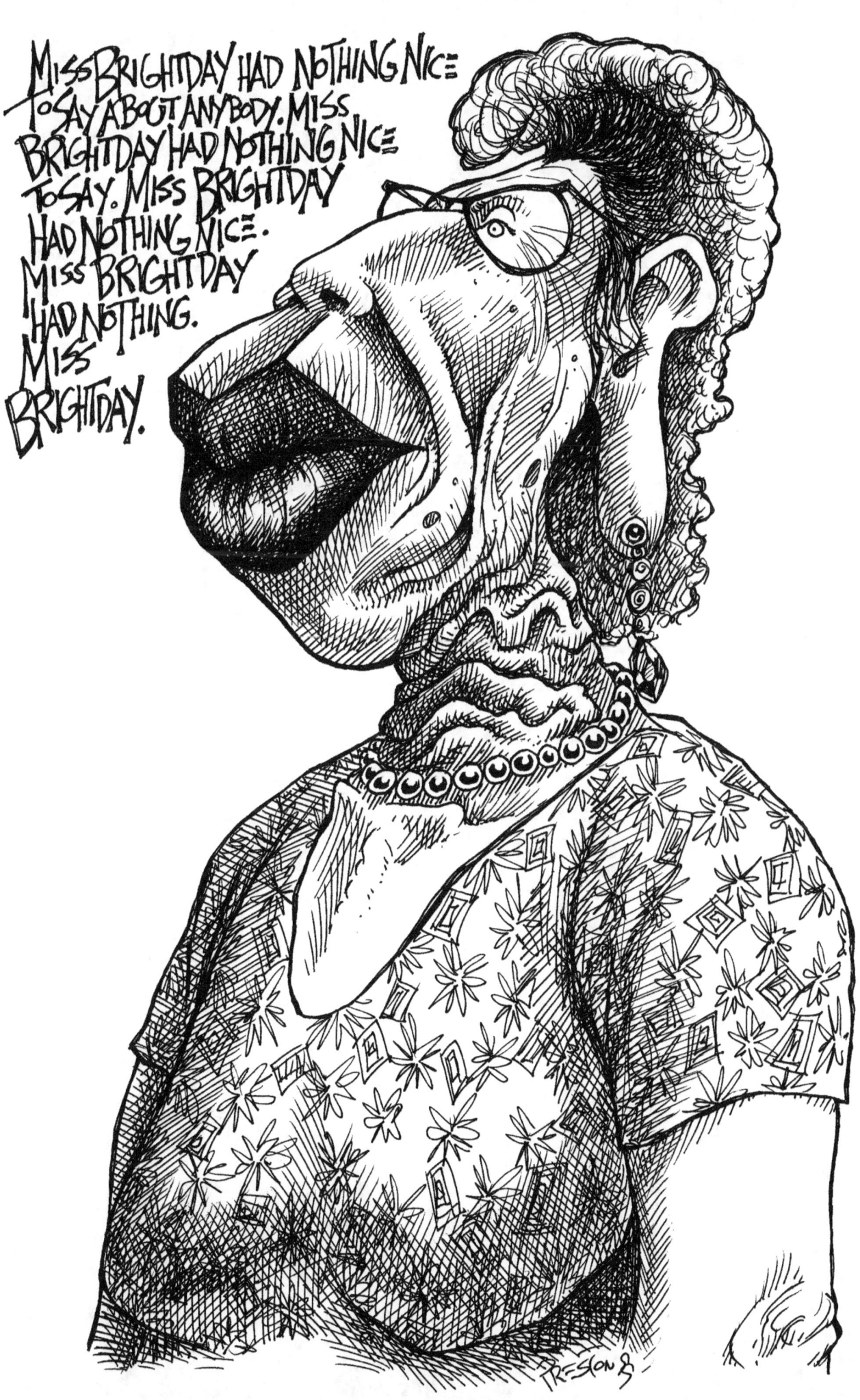

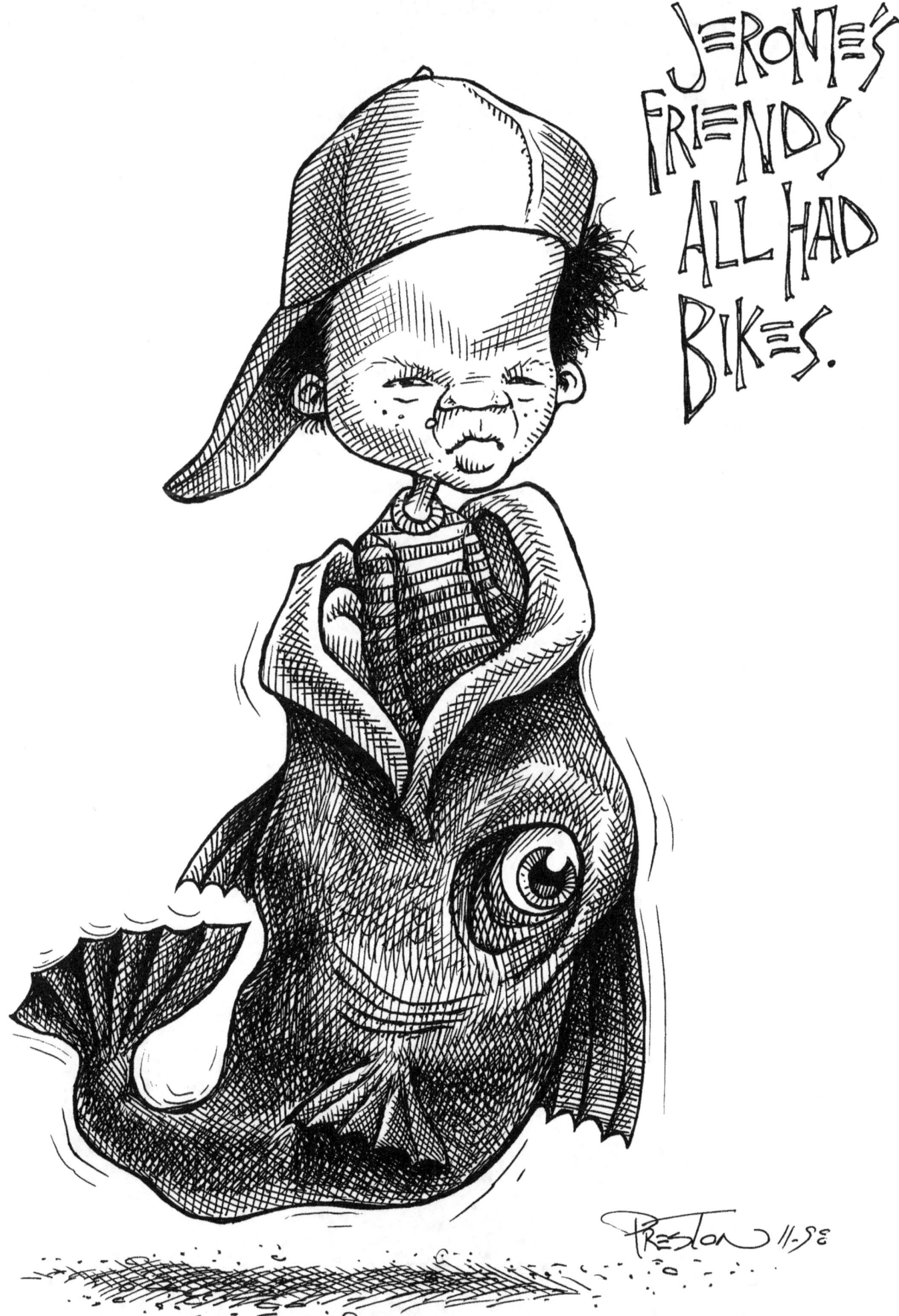

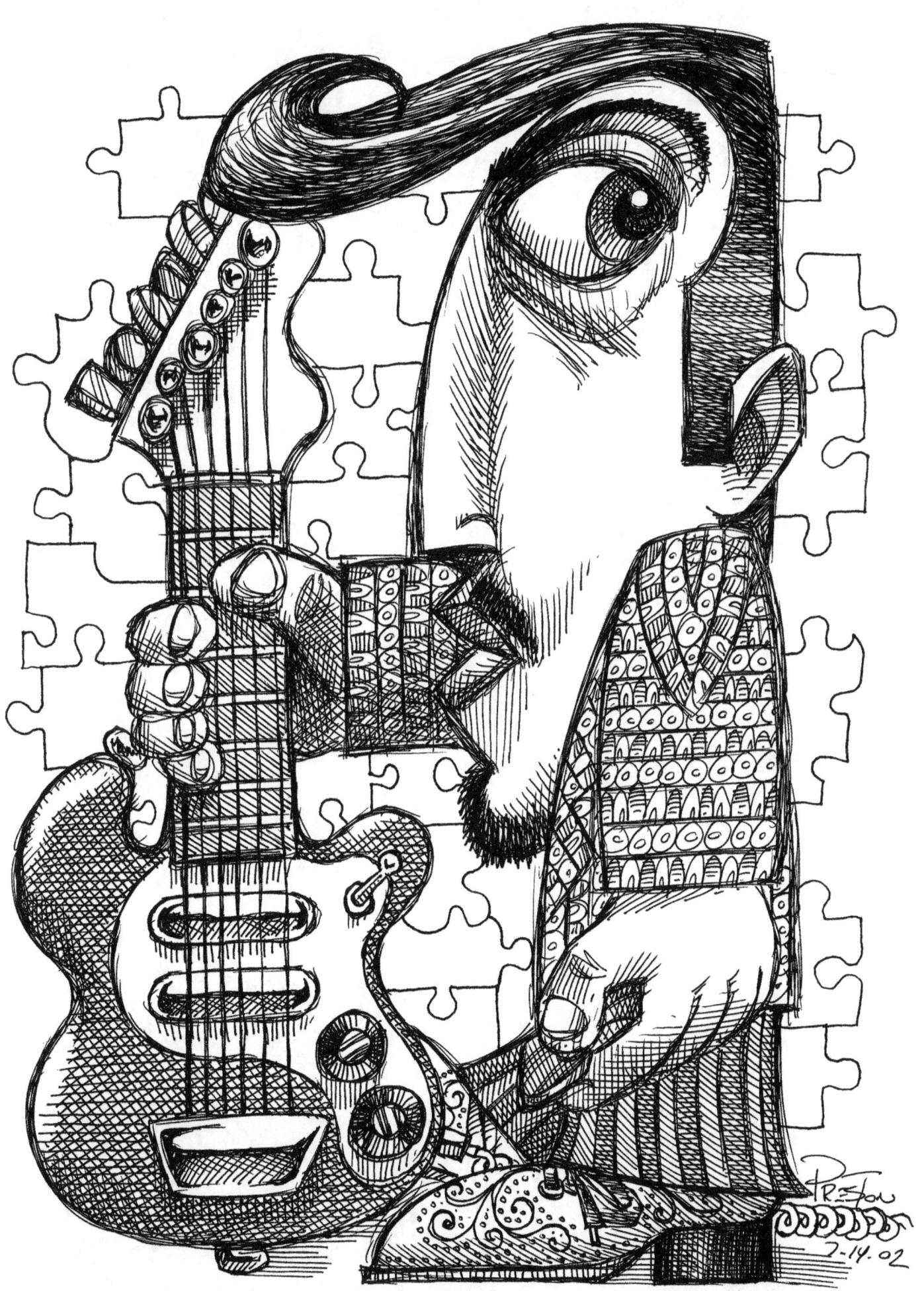

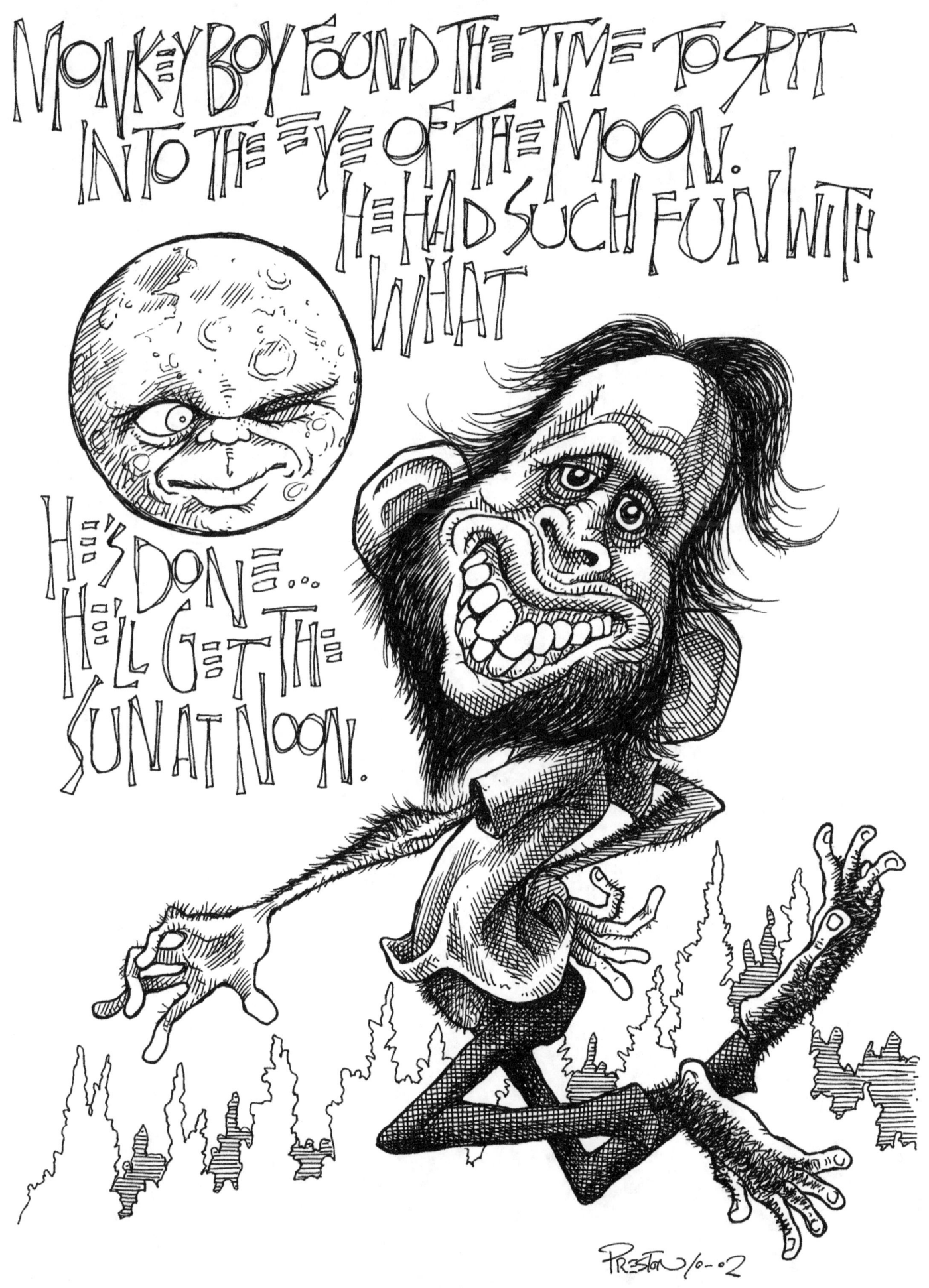

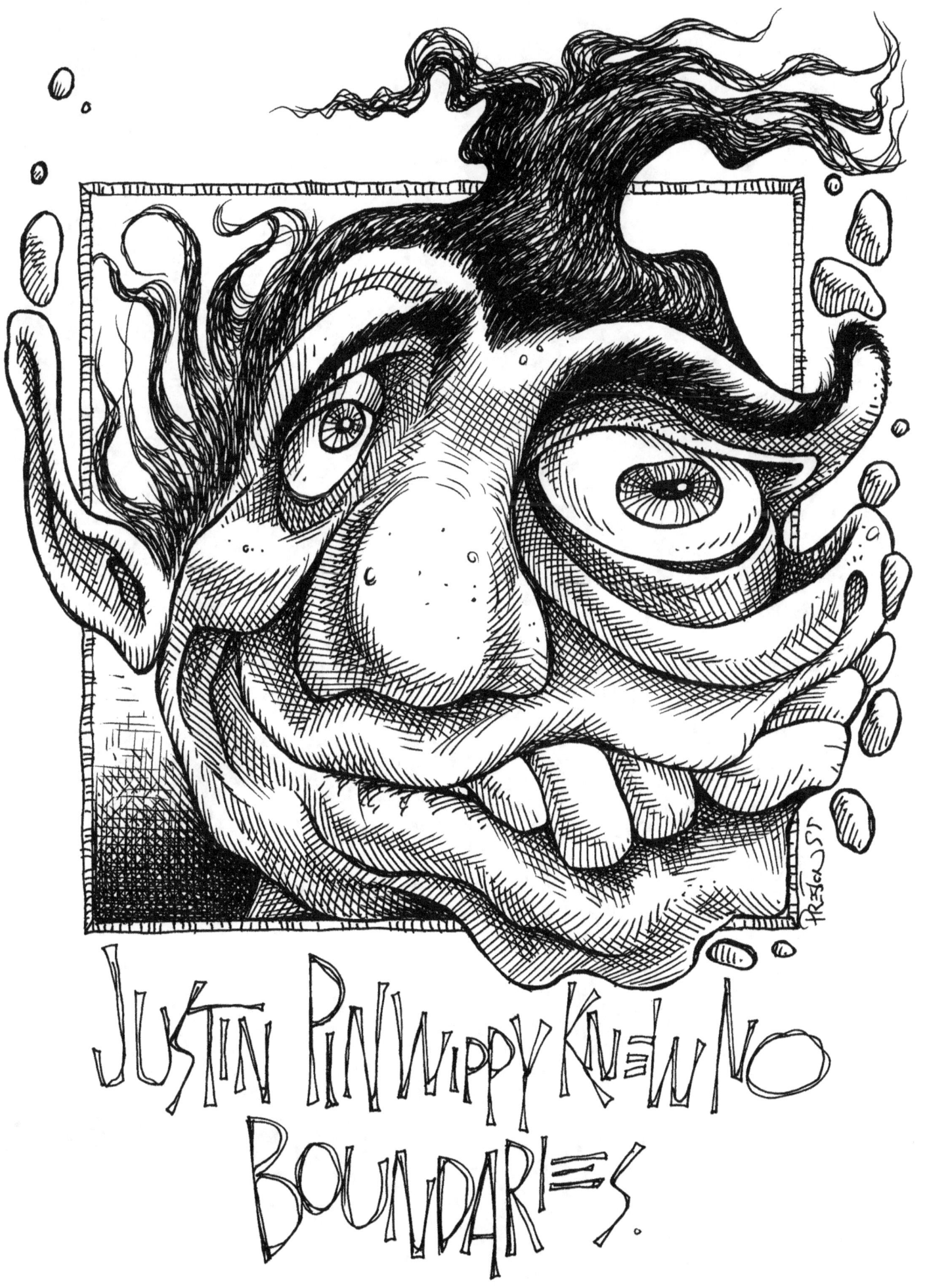

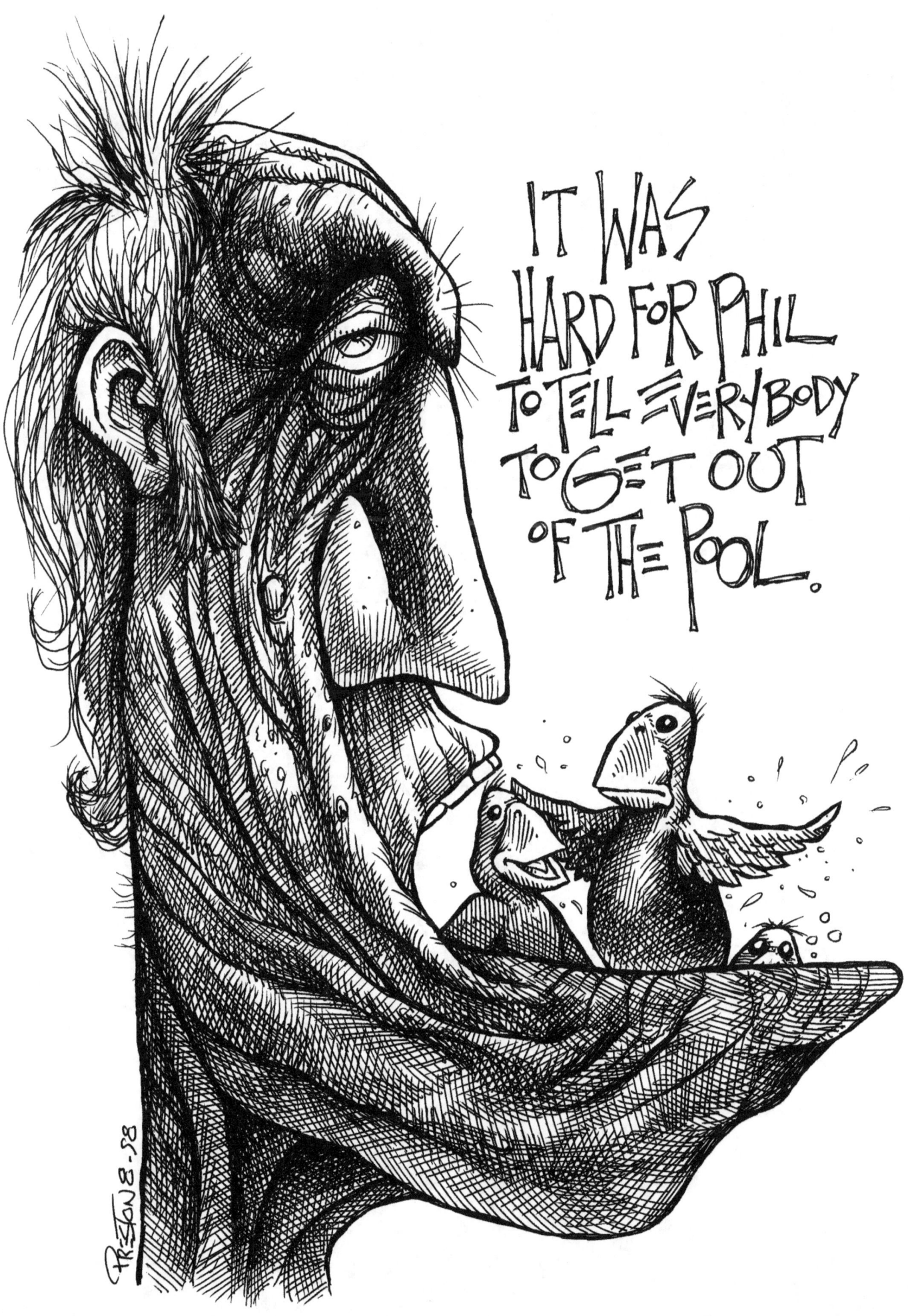

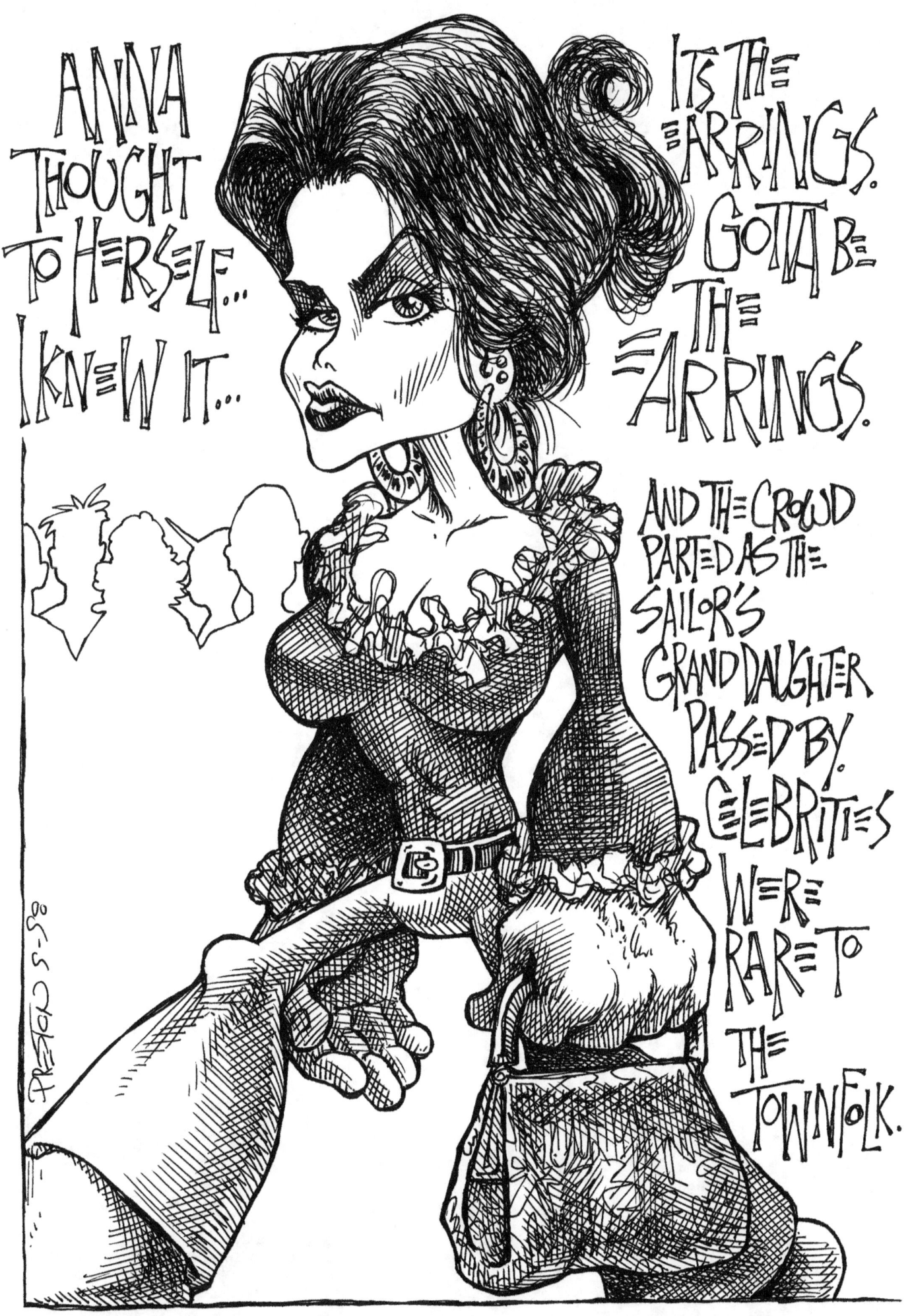

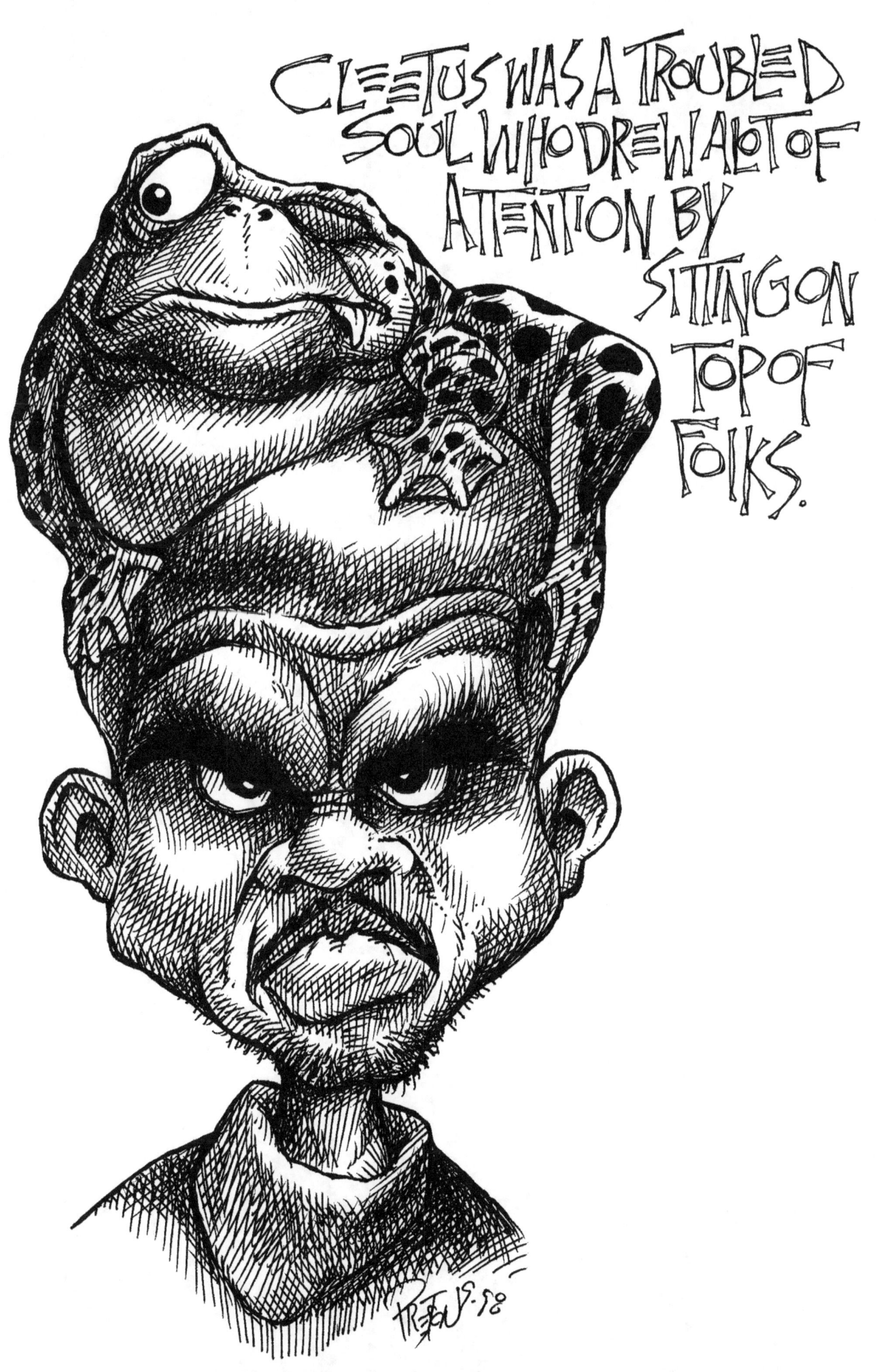

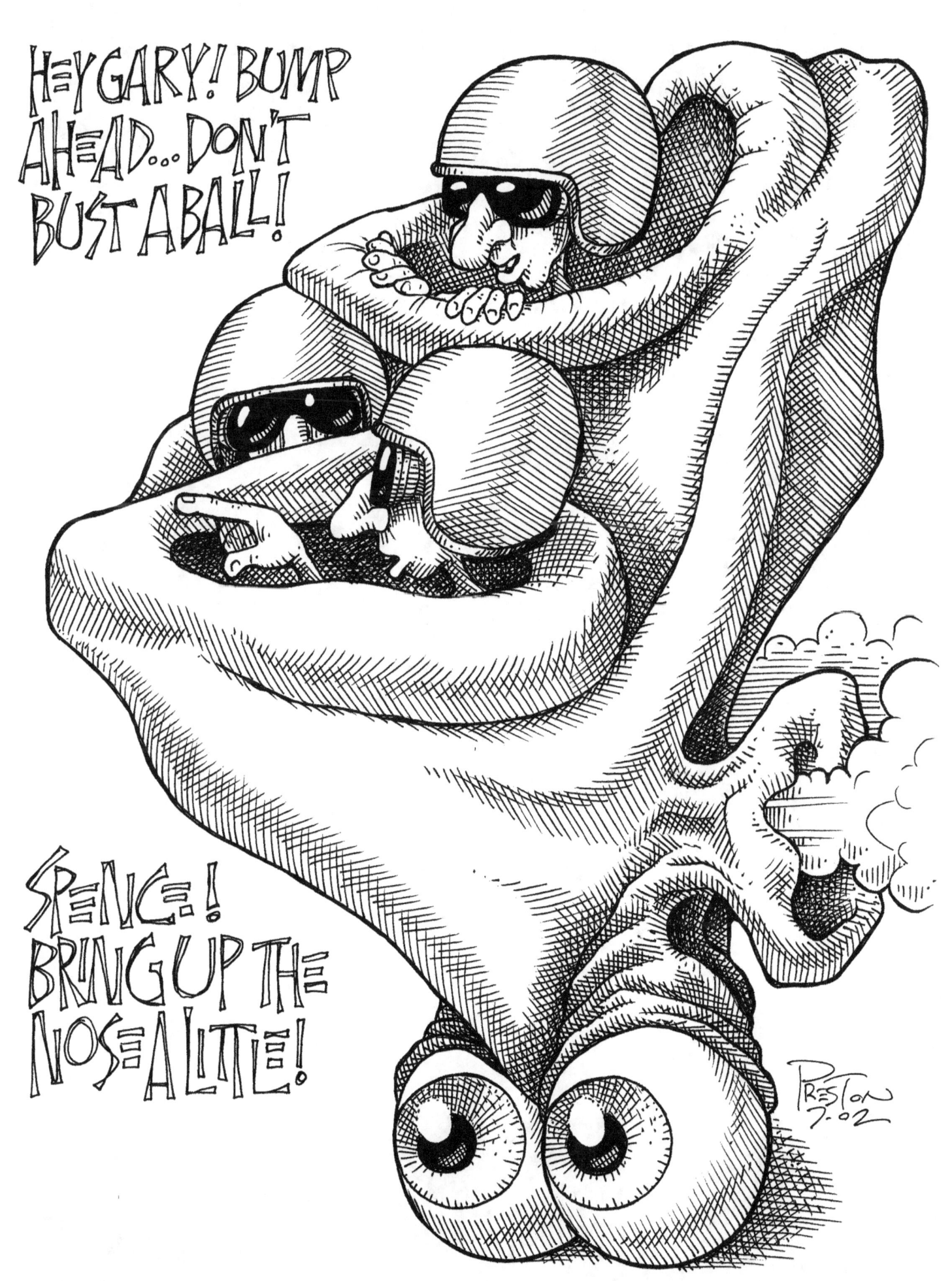

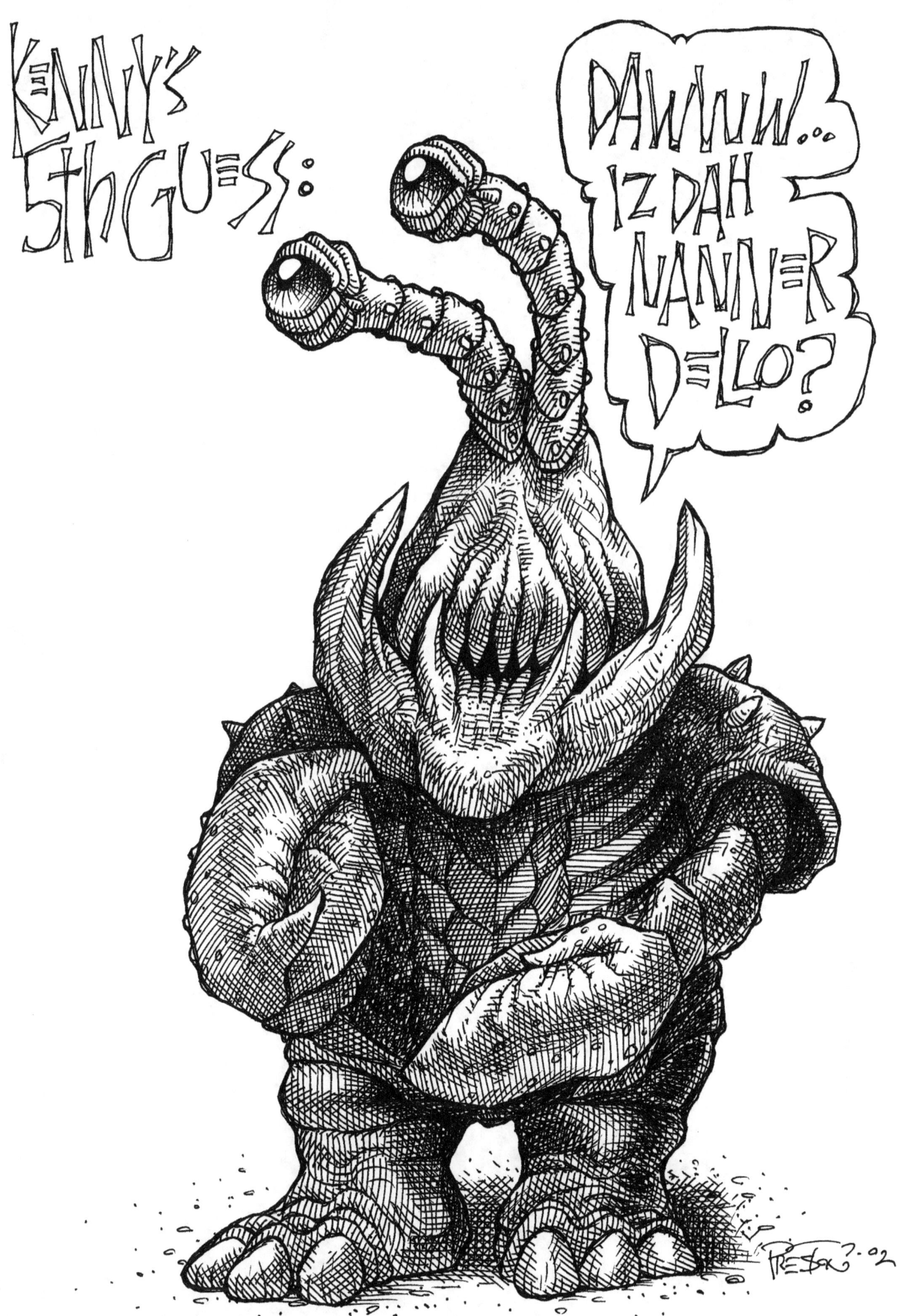

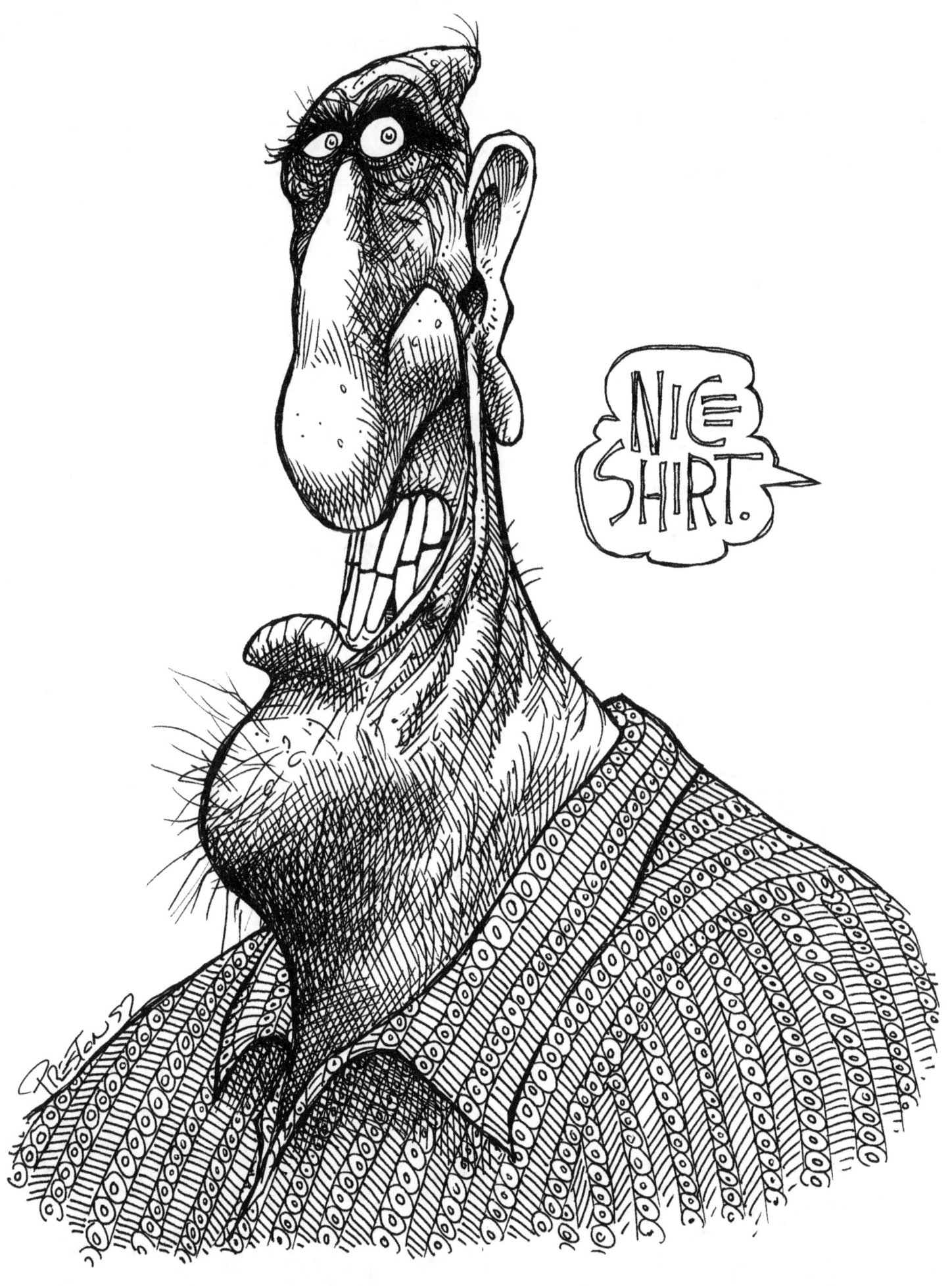

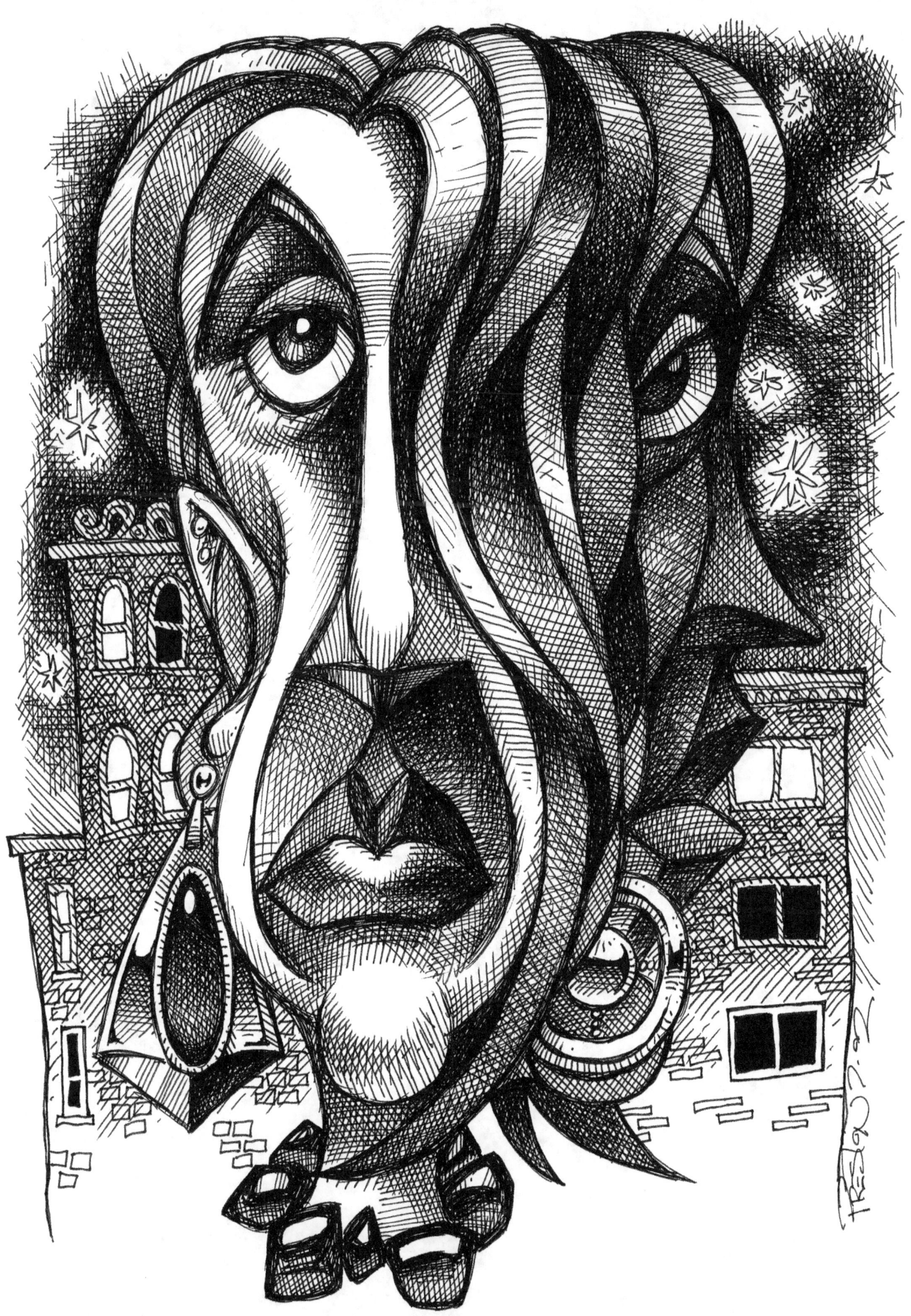

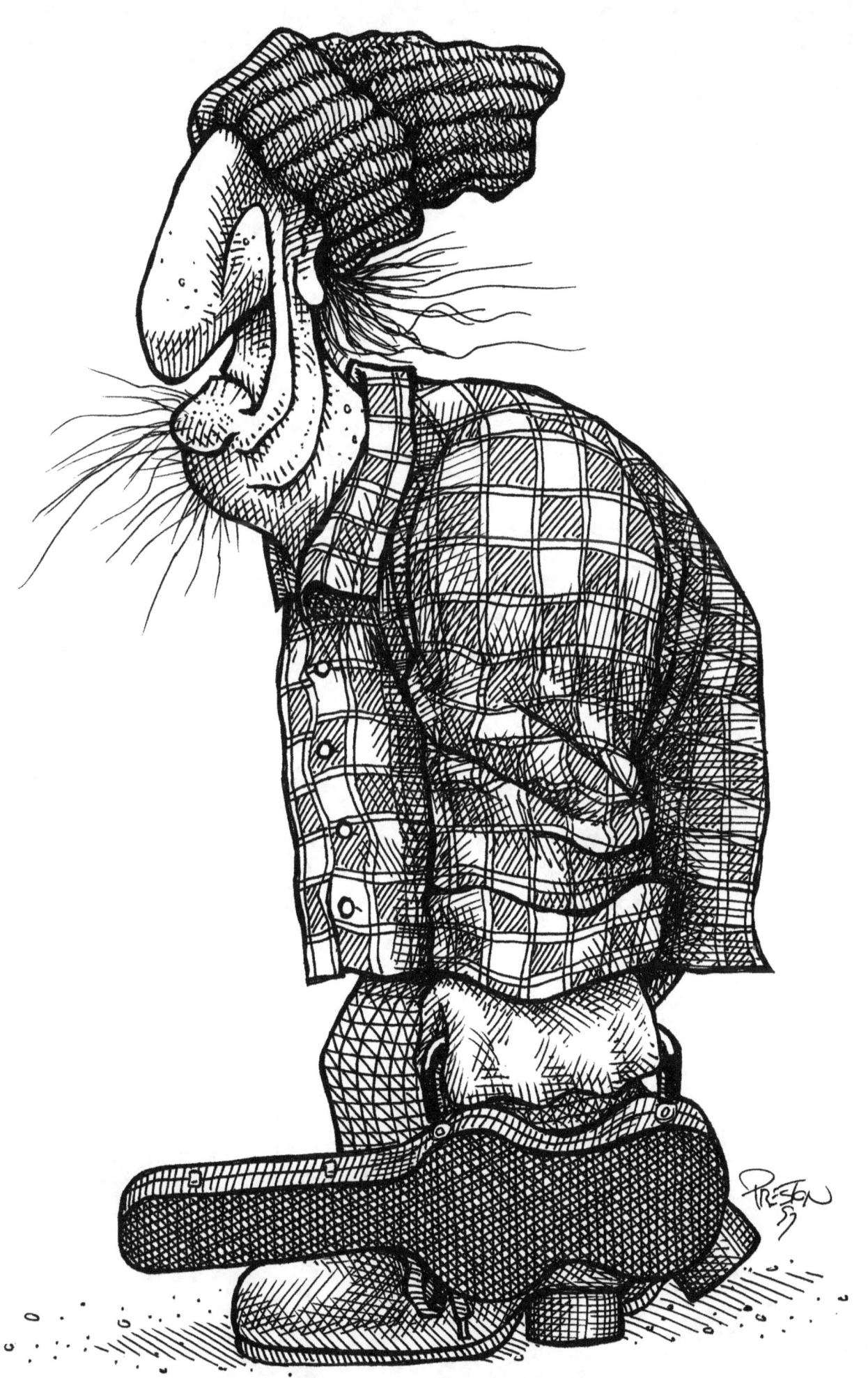

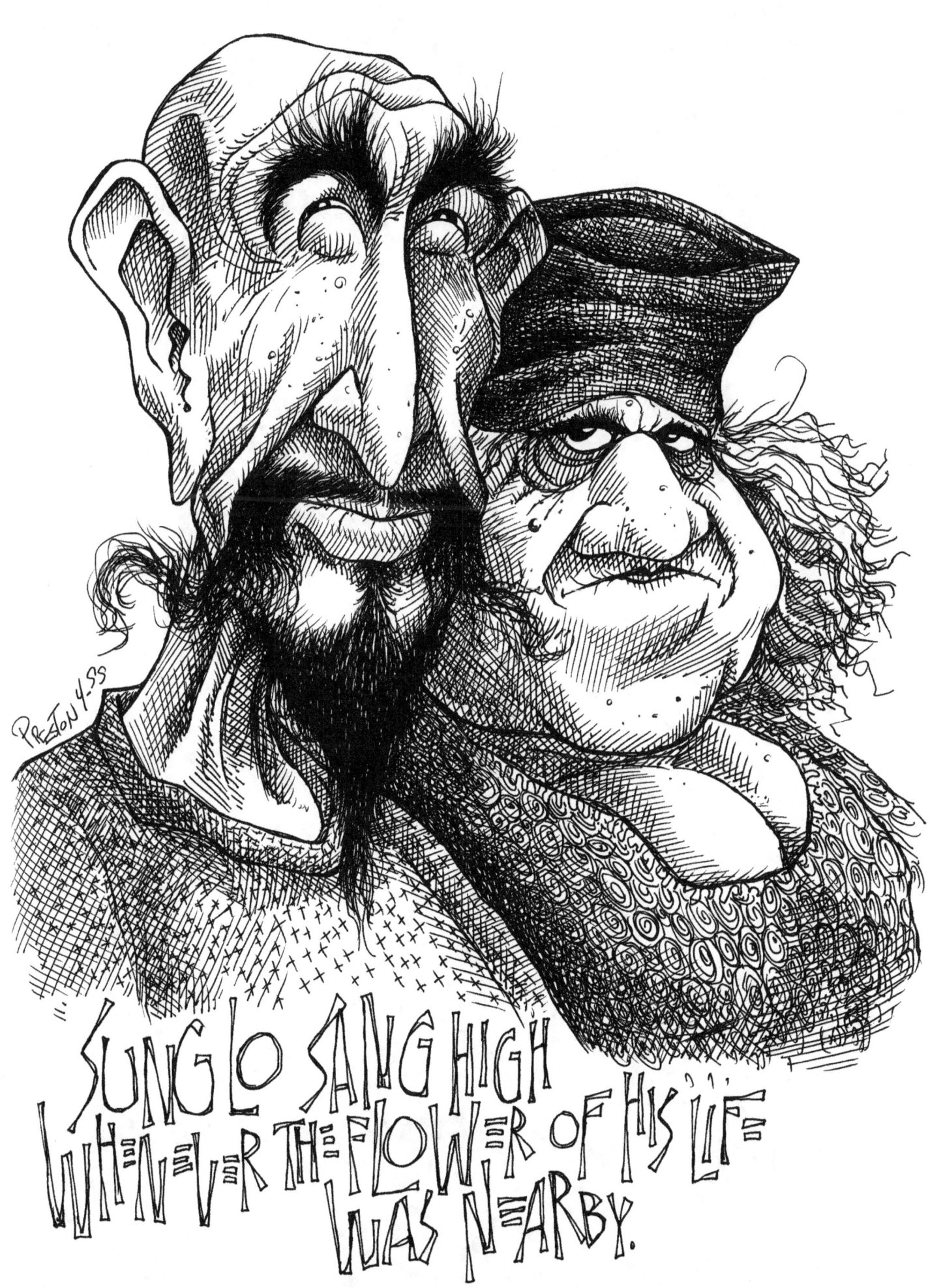

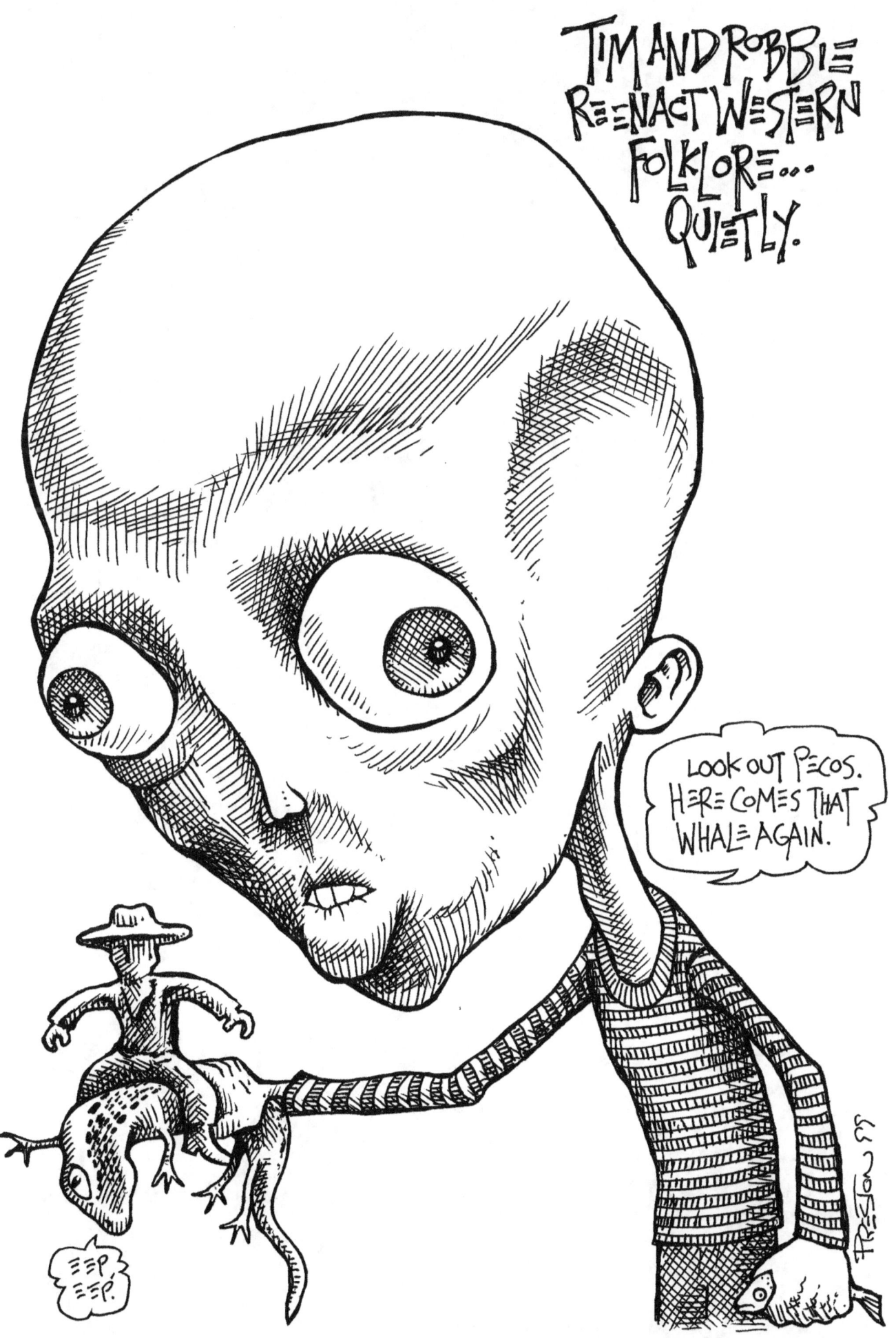

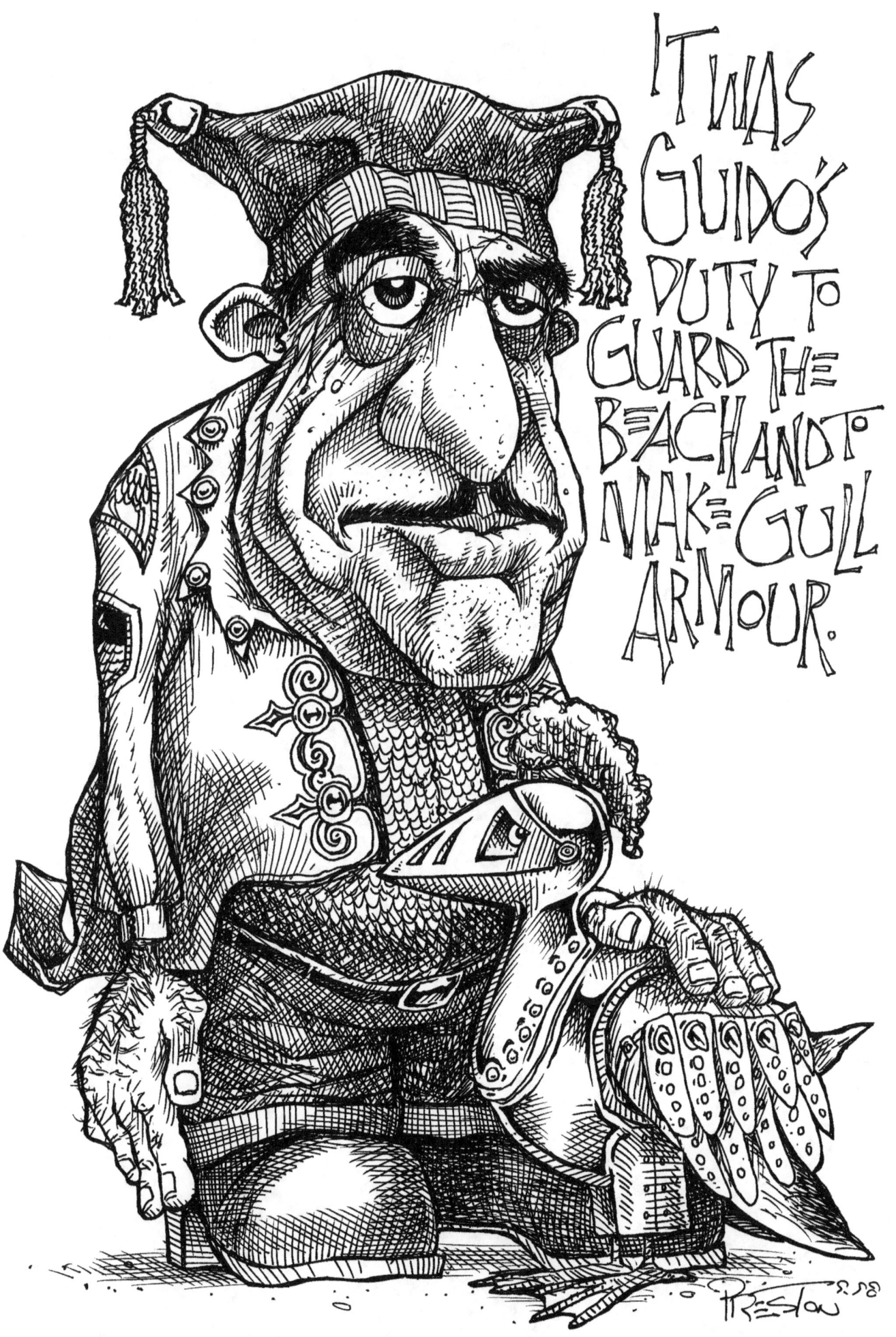

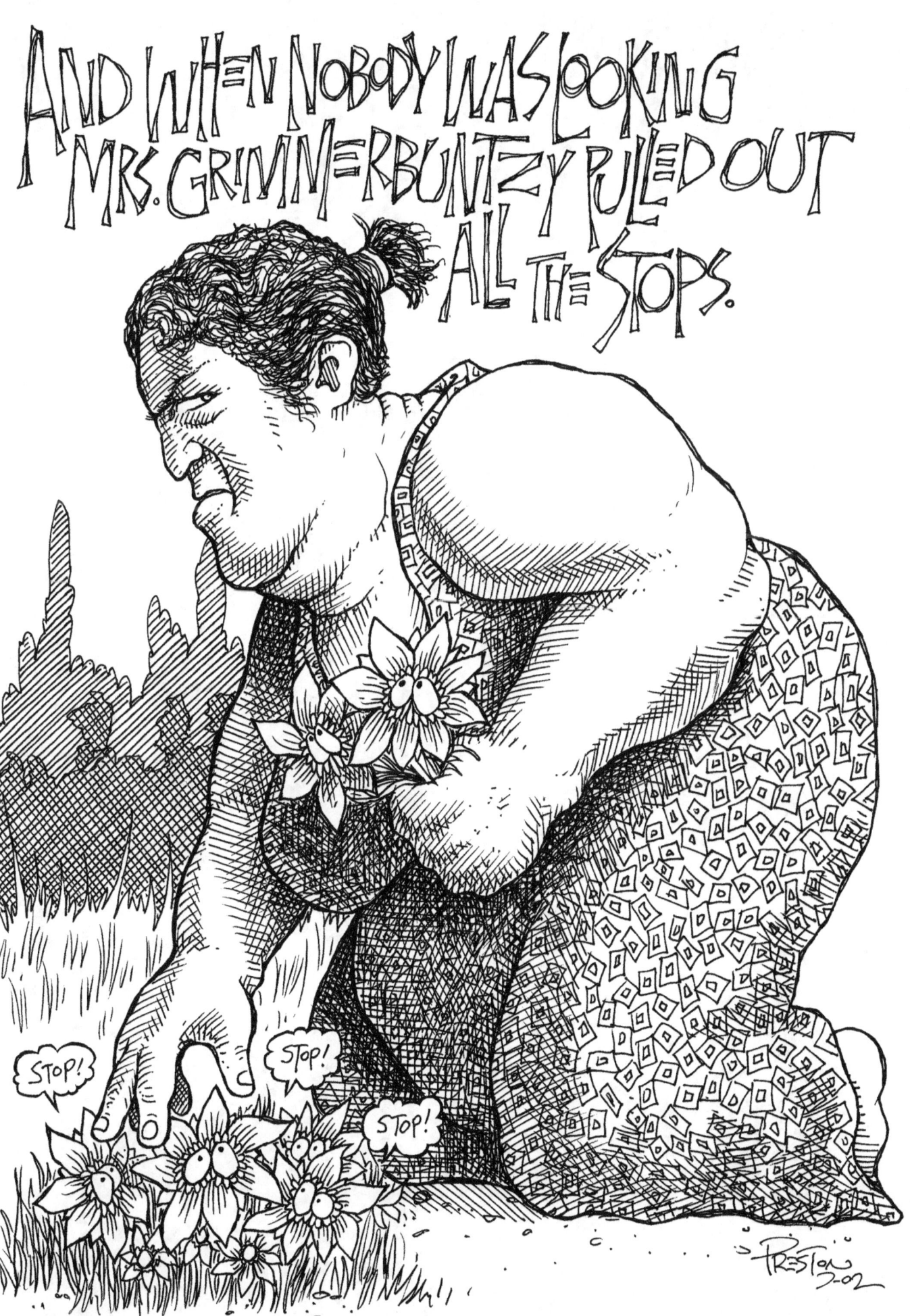

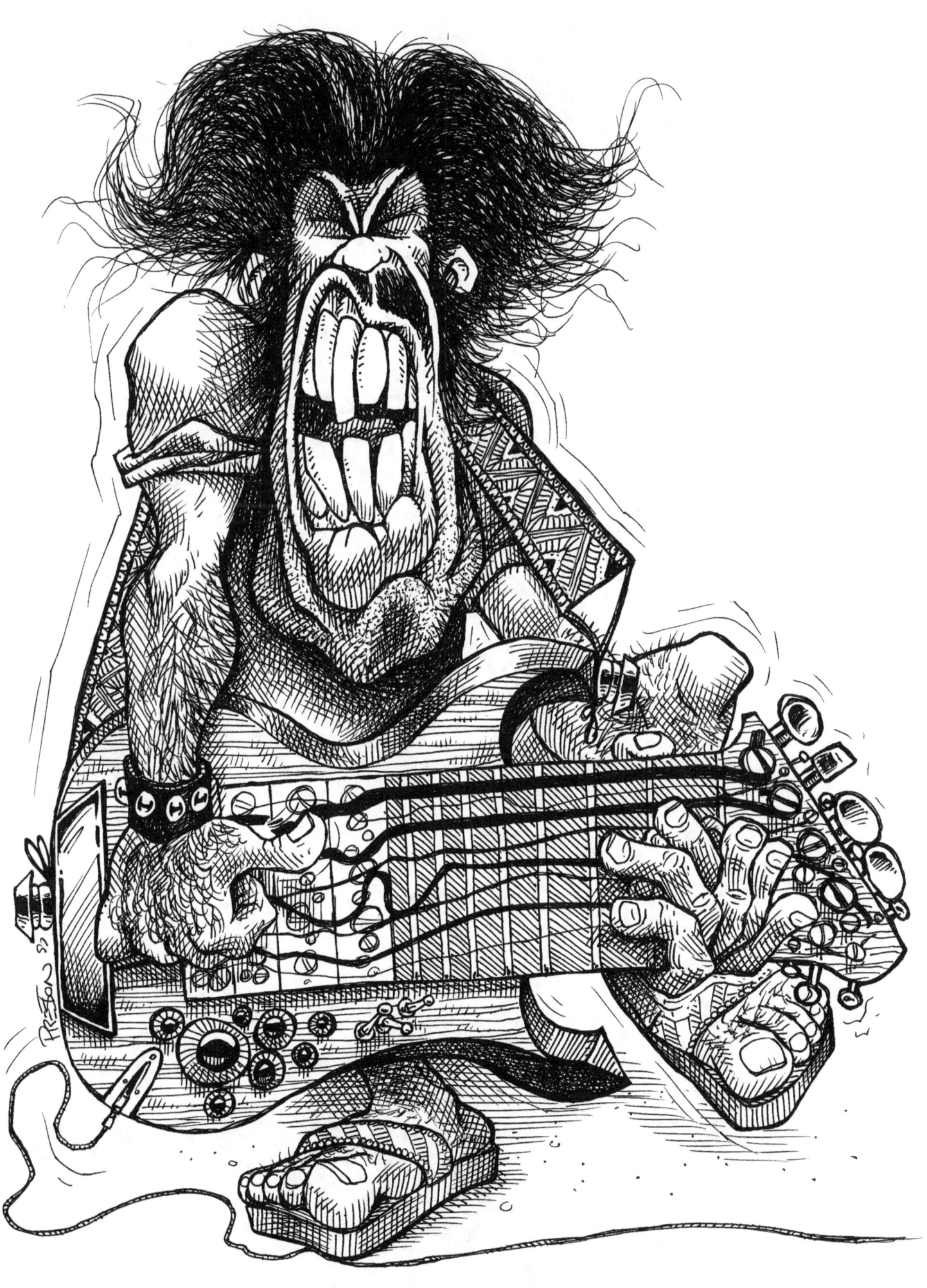

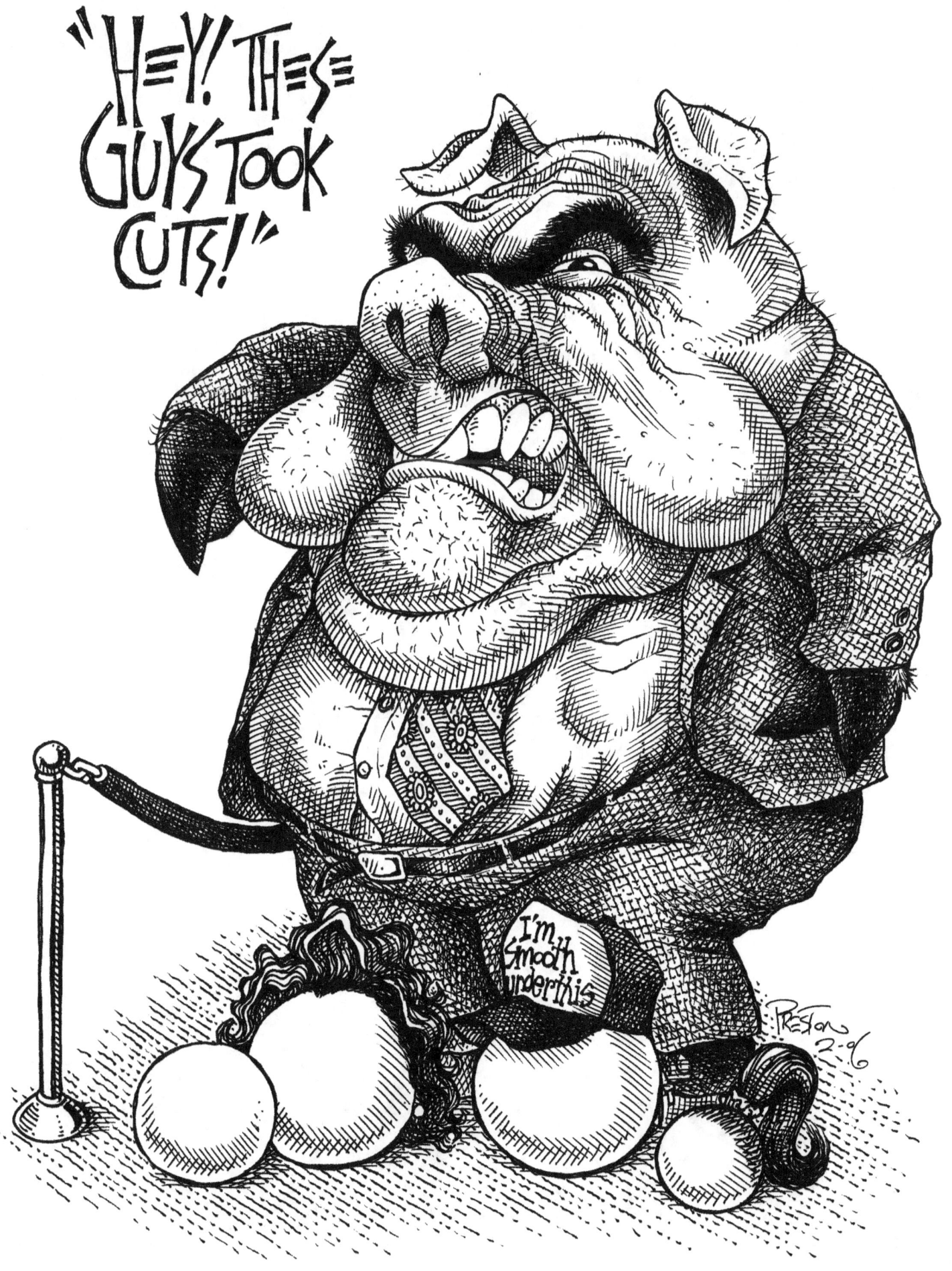

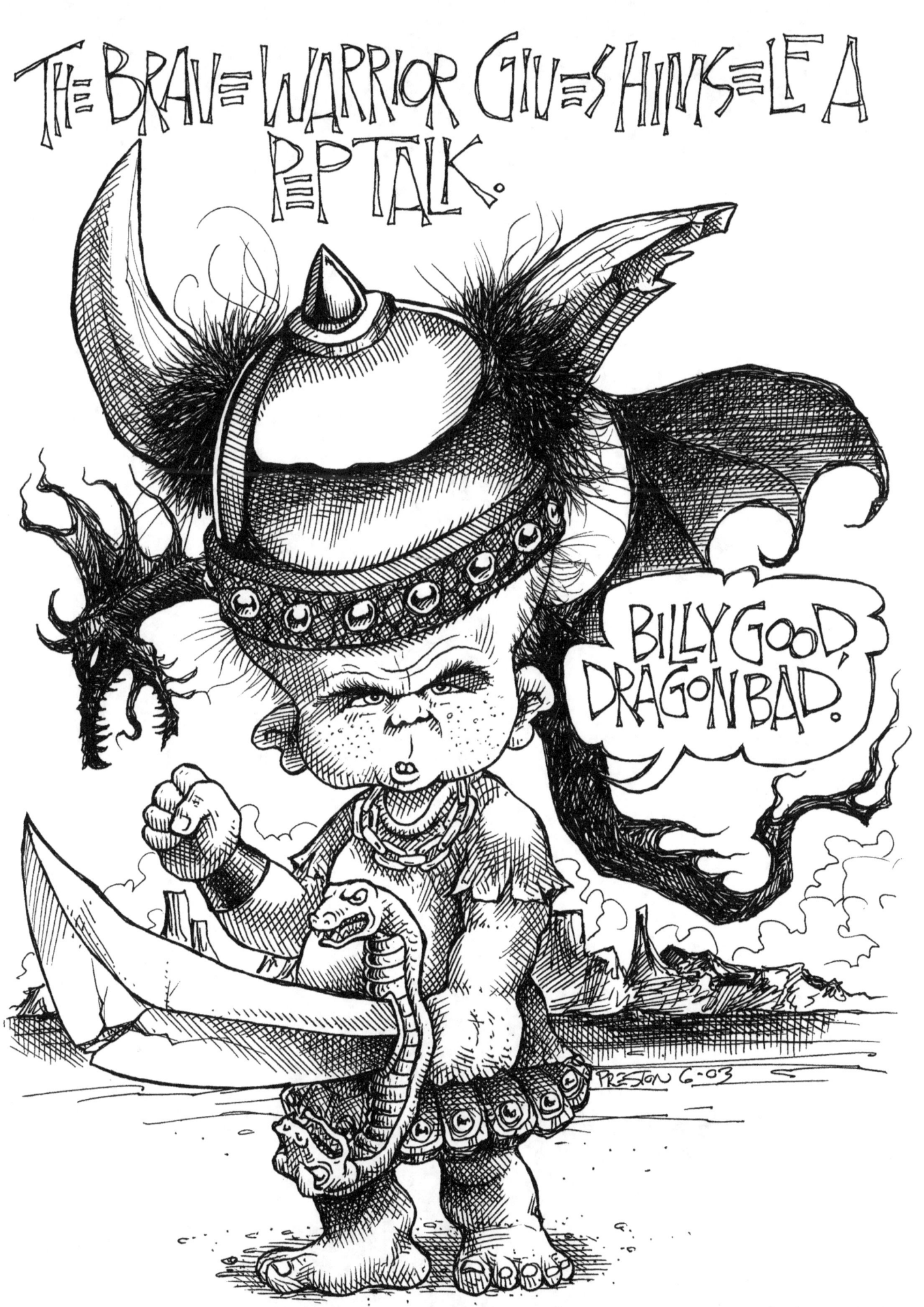

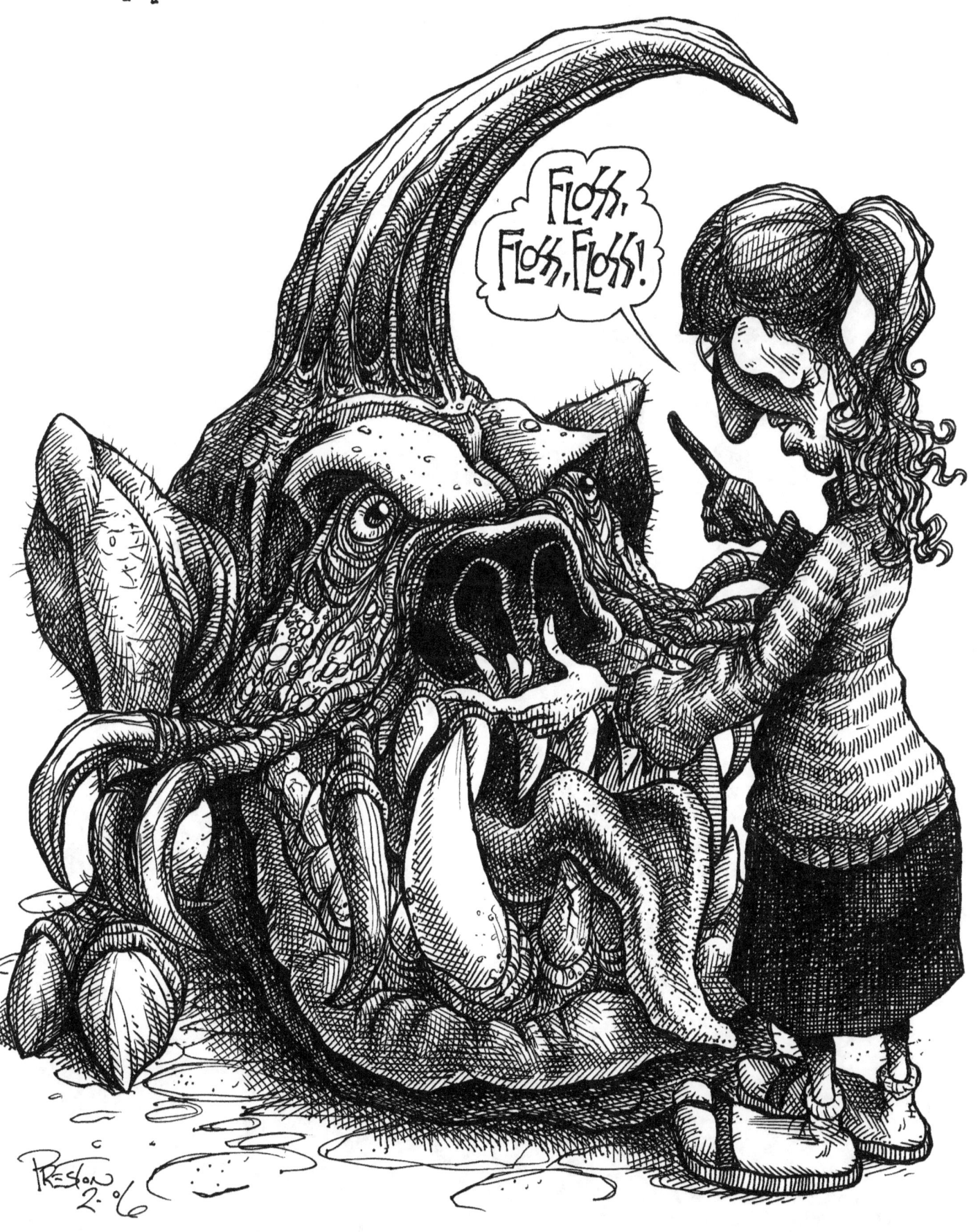

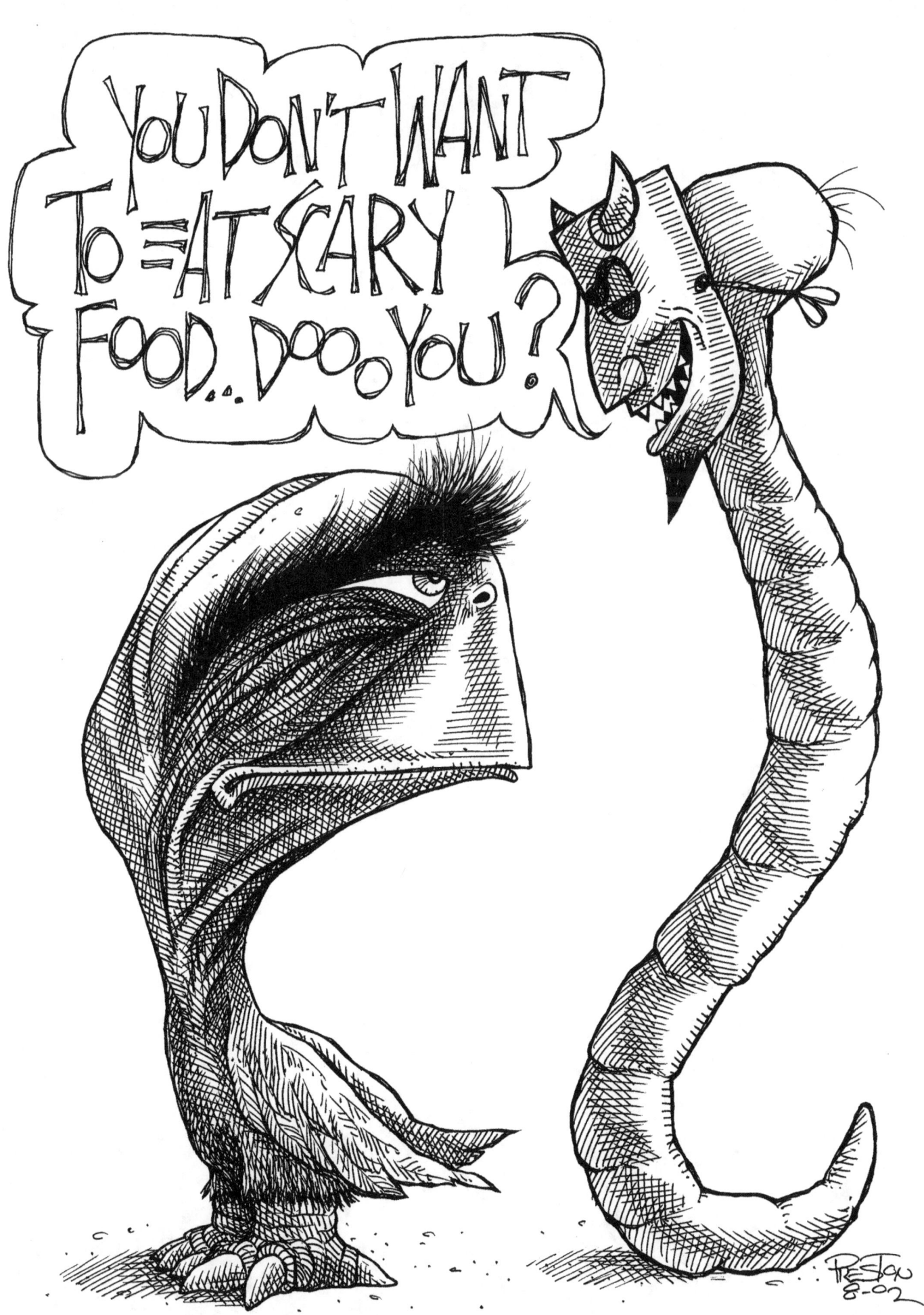

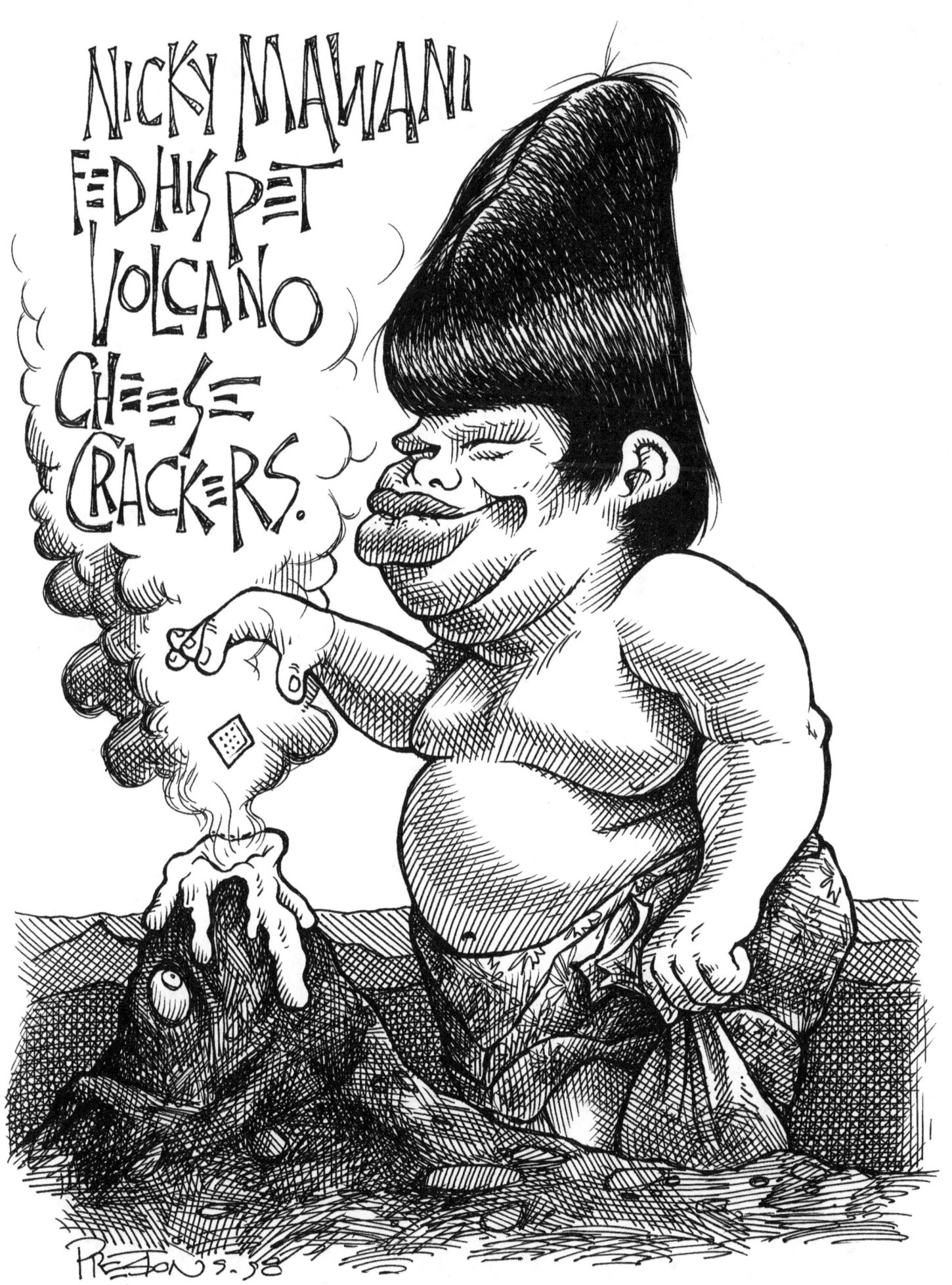

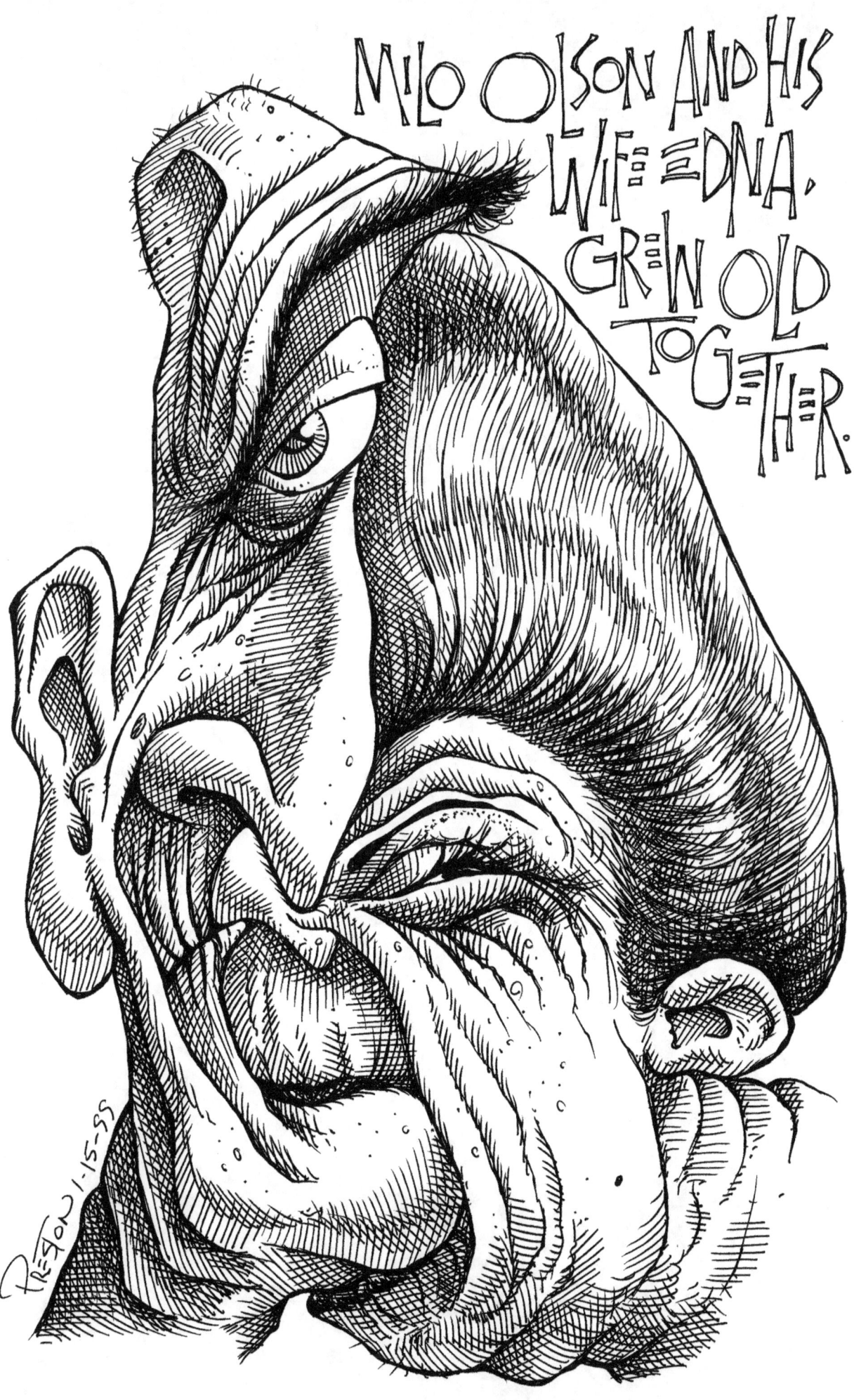

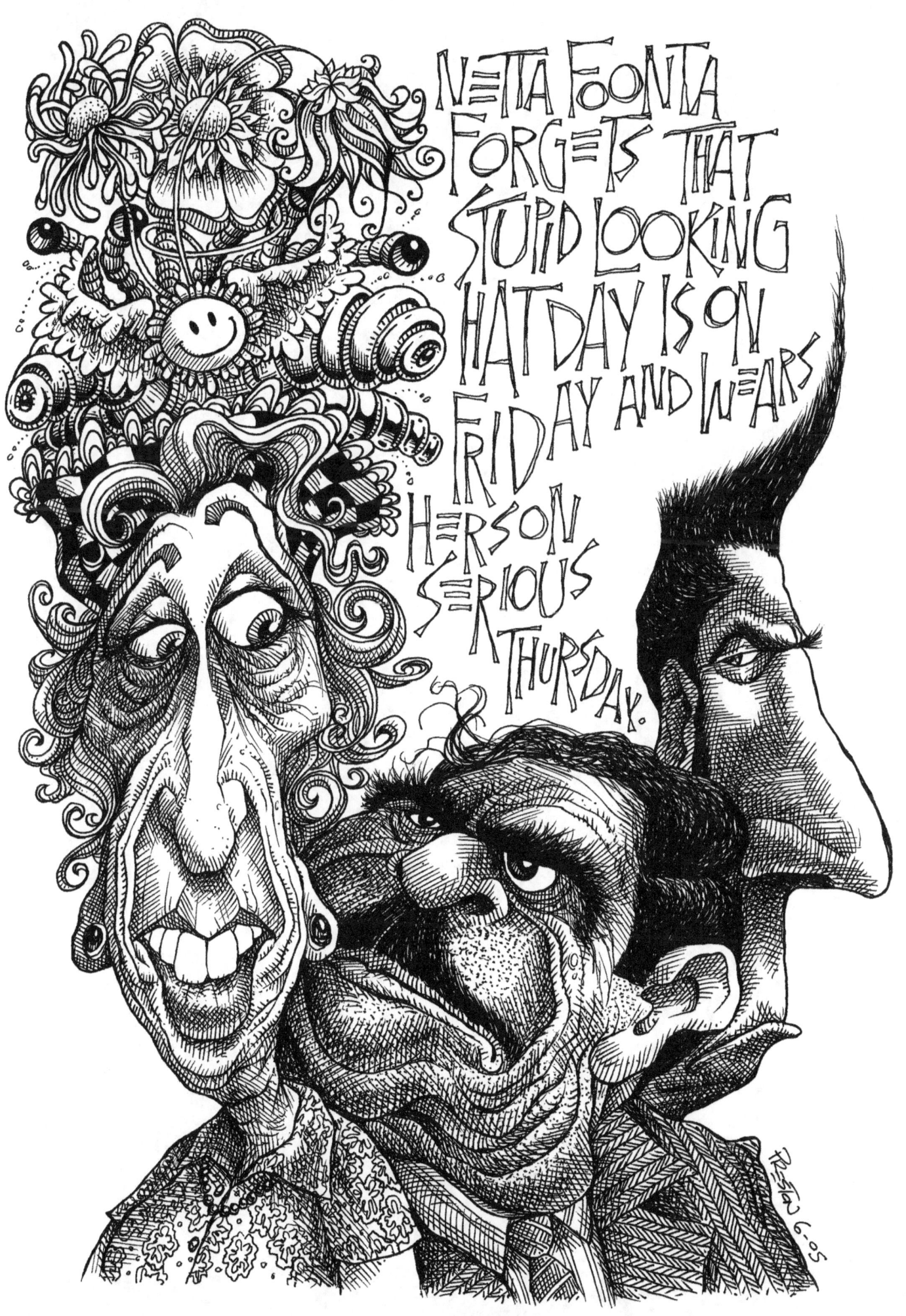

People began to leave the party when Ted showed off his double jointed features.

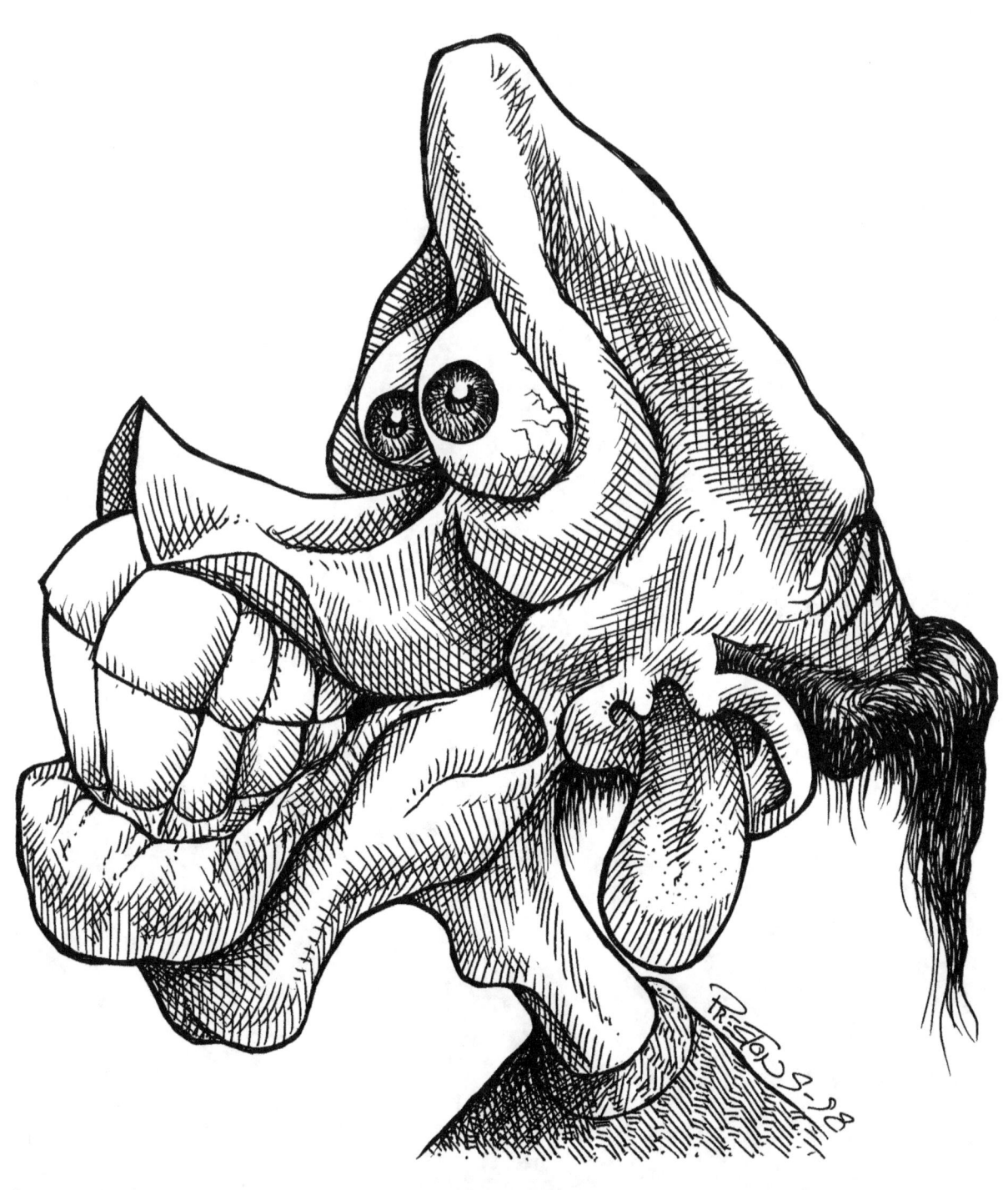

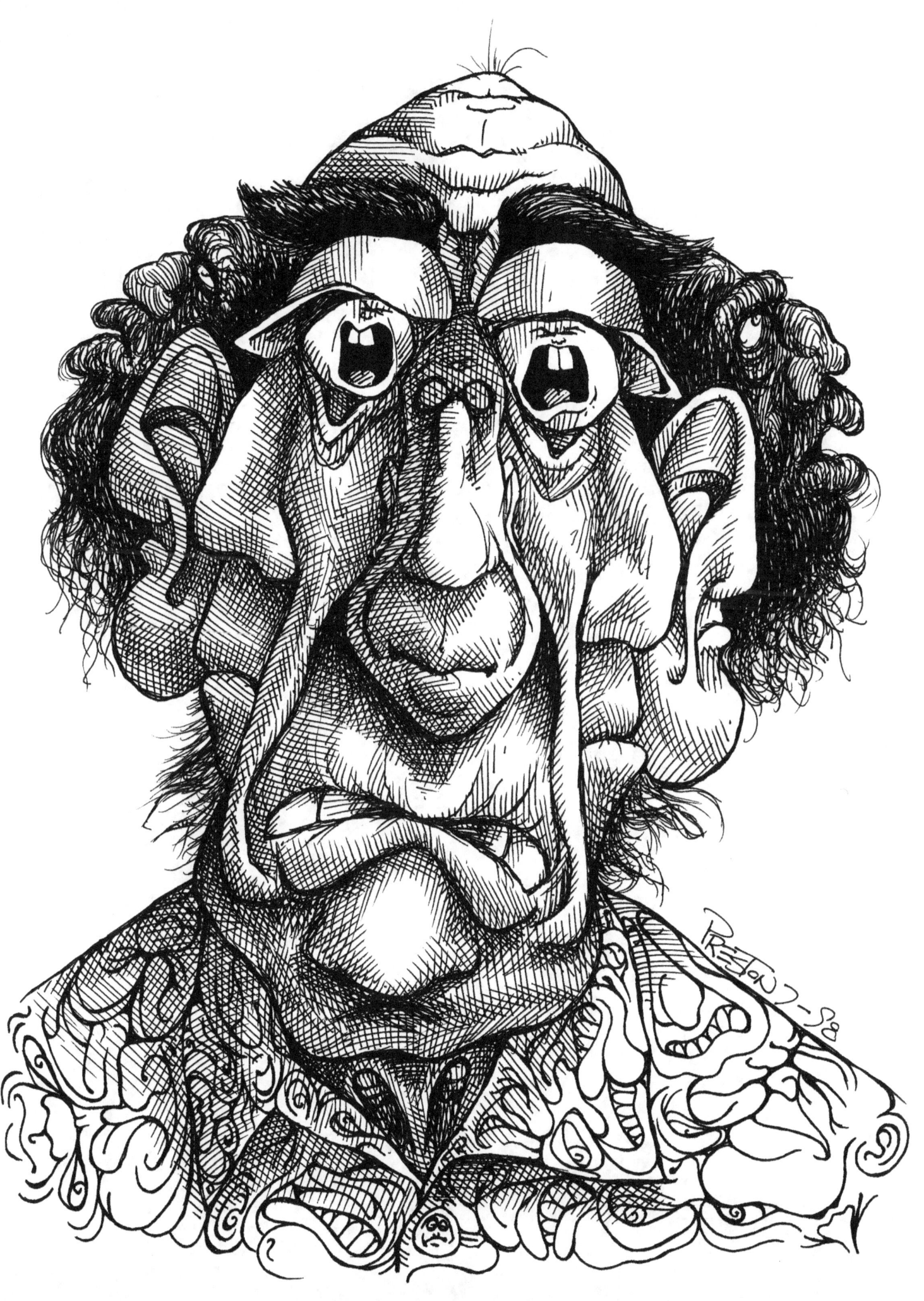